# WORLD
# FILM
# LOCATIONS
# VANCOUVER

Edited by Rachel Walls

D0942317

First Published in the UK in 2013 by
Intellect Books, The Mill, Parnall Road,
Fishponds, Bristol, BS16 3JG, UK

First Published in the USA in 2013
by Intellect Books, The University of
Chicago Press, 1427 E. 60th Street,
Chicago, IL 60637, USA

Copyright ©2013 Intellect Ltd

Cover photo: *Blade Trinity* © 2004
Warner Bros / The Kobal Collection
/ Limot

Copy Editor: Emma Rhys

A Catalogue record for this book is
available from the British Library

**World Film Locations Series**
ISSN: 2045-9009
eISSN: 2045-9017

**World Film Locations Vancouver**
ISBN: 978-1-84150-721-7
eISBN: 978-1-84150-803-0

Printed and bound by
Bell & Bain Limited, Glasgow

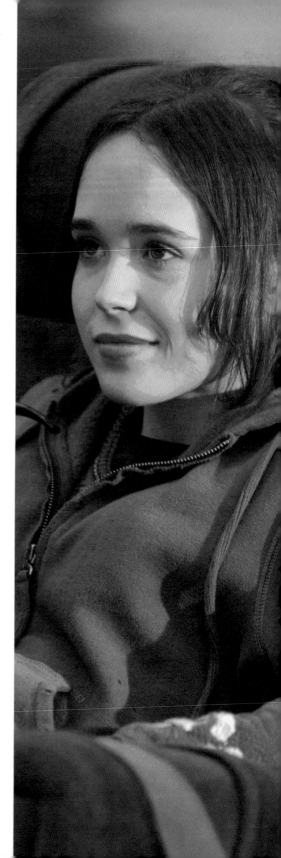

# WORLD
# FILM
# LOCATIONS
## VANCOUVER

EDITOR
Rachel Walls

SERIES EDITOR & DESIGN
Gabriel Solomons

CONTRIBUTORS
Neale Barnholden, Elvy Del Bianco,
Colin Browne, Diane Burgess,
Karrmen Crey, Scott Jordan Harris,
Flick Harrison, David Hauka,
Edward Hyatt, Randolph Jordan,
Amy Kazymerchyk, Peter Lester,
Laurynas Navidauskas, Alex Nicola,
Angela Piccini, Lindsay Steenberg,
Kamala Todd, Michael Turner,
Carl Wilson, Ger Zielinski

LOCATION PHOTOGRAPHY
Andy Ji, Maia Joseph, Dennis Ha,
Sarah Banting, Dianne Burgess,
Flick Harrison, Paolo Bacaro,
David Hauka, Kevin Doherty
(unless otherwise credited)

LOCATION MAPS
Joel Keightley

PUBLISHED BY
Intellect
The Mill, Parnall Road,
Fishponds, Bristol, BS16 3JG. UK
T: +44 (0) 117 9589910
F: +44 (0) 117 9589911
E: *info@intellectbooks.com*

Bookends: Robson Square (Pic: Paola Bacaro)
This page: *Juno* (Kobal)
Overleaf: *I, Robot* (Kobal)

# CONTENTS

## ACKNOWLEDGEMENTS

I am extremely grateful to all the writers who contributed essays and scene reviews as well as additional information and ideas. Many thanks also to the photographers who provided the contemporary shots of Vancouver and to the film-makers who imparted information and help on request. Finally, thanks to the series editor, Gabriel Solomons, for his guidance and to other Intellect team members involved with the project.

RACHEL WALLS

# INTRODUCTION

## *World Film Locations* Vancouver

THE WORLD FILM LOCATIONS SERIES has brought to readers iconic scenes and settings from global metropolises such as New York and Paris, and has uncovered the cinematic riches of smaller cities including Reykjavík and Dublin. Situated on the west coast of Canada in the province of British Columbia, Vancouver is the fourth largest film and television production centre in North America. It regularly hosts international film crews, yet its home cinema has received less recognition than it deserves. This edition, therefore, has a dual role: sharing the imaginative reinventions of Vancouver as international locations in Hollywood movies, and highlighting an impressive range of independent films that reveal Vancouver's multifaceted identity.

Through the lens of these films, this volume introduces you to Vancouver's diverse neighbourhoods and populations, its triumphs and injustices. Best known for its magnificent natural surroundings, Vancouver's urban environment has been shaped by a combination of First Nations, European and Asian influences, plus the imprints of industry and its decline, planning and design ('Vancouverism') and mega-events (Expo '86 and the 2010 Winter Olympics). This volume gestures towards the city's complexity by highlighting locations iconic and unknown, new and old (some now destroyed), downtown and suburban, wealthy and deprived.

Your cinematic tour of the city begins with Colin Browne's 'Vancouver: City of the Imagination', an introduction to early Vancouver films, the beginnings of the industry and achievements of film-makers since. Subsequently, the scene reviews shed light on scenes in 38 films, made by local and international film-makers between 1927 and 2011, using City of Vancouver (and adjacent University Endowment Land) locations. These are accompanied by colour images of the scenes in question, alongside contemporary comparison shots taken especially for this book. Interspersed are six spotlight essays which focus on the following topics: the masking of Vancouver's indigenous stories and communities in Hollywood representations of the city; Australian screenwriter James Clavell's Vancouver-set debut *The Sweet and the Bitter* (1967); Sylvia Spring's *Madeleine Is …* (1971), the first female-directed feature in Canada; Jonathan Kaplan's *The Accused* (1988), for which Jodie Foster won an Oscar; the representation of Vancouver in the films of Bruce Sweeney; and the use of Vancouver locations in US television crime series.

As the book's concluding scene reviews demonstrate, Hollywood continues to bring big budgets and talent to Vancouver. Moreover, the city continues to inspire productions made and set in Vancouver. At the time of writing, sci-fi series *Continuum* (Simon Barry, 2012–present) concluded a high-rated debut run on Showcase, while film-maker Loretta Todd prepares to pilot television series *Skye and Chang* on the Aboriginal Peoples Television Network (APTN). Bruce Sweeney's *The Crimes of Mike Reckett*, Terry Miles and Kristine Cofsky's *In No Particular Order* and Mark Sawers *Camera Shy* premiered at the 2012 Vancouver International Film Festival.

For those intrigued by Vancouver and film, the future looks promising. For now, I hope you'll enjoy the images and insights provided by this volume. From downtown danger and railroad run-ins to roadside romance and high-rise heartbreak, here is your guide to Vancouver's film locations. ✢

### Rachel Walls, Editor

# VANCOUVER

Text by
COLIN
BROWNE

## City of the Imagination

**BUILT OVER AND AROUND** several vital Coast Salish villages, the city of Vancouver is barely 125 years old. Its incorporation as a link in the global economy resembled the launching of a space station, coinciding with the publication of Rimbaud's *Illuminations* (1886), the surrender of Geronimo, and the development of the rotating scanning device that laid the ground for television. Vancouver was an early manifestation of the *virtual* city – fluid, fragmented, provisional and always *becoming* – always the city of the future. New immigrants projected onto its scenery their dreams of a second chance, and real-estate investors prospered.

The first cinematographer to arrive in Vancouver was 27-year-old Billy Bitzer. In 1899 he travelled through British Columbia with a hand-cranked movie camera for the American Mutoscope and Biograph Company. None of his Vancouver reels remain; the two that have survived are thrill rides shot from the point of view of a steam engine's cowcatcher. The Canadian Pacific Railway (CPR) quickly recognized the promotional value of these reels and over the next two years produced at least 21 of its own featuring the railway and British Columbia's fishing, canning, logging and export industries. Distributed as 'educational' films, they were more accurately promotional reels, selling Canada and the railway to prospective tourists, immigrants and investors.

Travelogues were popular. American cinematographer William Harbeck filmed through the front window of a streetcar travelling down Hastings Street in May 1907, four months before Vancouver's Asiatic Exclusion League riots. The city also appears in a 1910 CPR production entitled *A Wedding Trip from Montreal through Canada to Hong Kong*. In this one-reeler – the first dramatic film shot in Vancouver – Lovey and Dearie fall in love on the train west and get married in Vancouver before setting out for the Far East. The cast and crew, from the Edison Manufacturing Company in New York, made a dozen promotional dramas on location during that summer, establishing a pattern that continues to this day: Vancouver as a location.

The CPR was one of two dominant producers of films in British Columbia until the late-1950s. The other was the Dominion government through the National Film Board (NFB) of Canada and its precursor, the Canadian Motion Picture Bureau. *Queen of the Coast* (1920), the Bureau's first Vancouver travelogue, established a template for the travelogues and industrials that followed. Newsreels from Vancouver began to appear after World War I. NFB wartime productions like *War Clouds in the Pacific* (1941) and *Gateway to Asia* (1945) were screened across North America. When the NFB opened its Pacific Studio in Vancouver in the late-1970s, it became a hub for regional documentary and dramatic productions including those by independent film-makers.

By the 1920s, Vancouver was being marketed as the 'Film Capital of the British Empire', a claim promoters hoped would be underwritten by the 1926 British quota legislation. Investors were wooed, money passed hands and the promoters often fled, but Vancouver did not give up on the idea of becoming 'Hollywood North', and the dream eventually came true thanks, in part, to a favourable exchange rate. The 'service industry' arrived in Vancouver in the late-1970s and its presence (think *The X-Files* [Chris Carter, Fox, 1993–2002], *Stargate SG-1* [Brad Wright and Jonathan Glassner, Showtime and Sci-fi Channel, 1997–2007], and *Smallville* [Miles Millar and Alfred Gough, WB and CB Networks, 2001–11]) has made Vancouver the fourth largest film and television production centre in North America. Some became indignant when the studios dressed Vancouver to look like Seattle or LA, but movies take place in symbolic, not real locations.

Canadian Broadcasting Corporation (CBC)

Vancouver played a critical role in the development of the city's film culture. Several ambitious television documentaries were made in the 1950s, among them Alan King's *Skidrow* (1956) – a prescient example of *cinema-vérité*. Important CBC Vancouver drama series, in particular *Cariboo Country* (Paul St. Pierre, 1960–67), *The Beachcombers* (Marc Strange and Lynn Susan Strange, 1972–90), *Da Vinci's Inquest* (Chris Haddock, 1998–2005), *Da Vinci's City Hall* (Chris Haddock, 2005–06), *Intelligence* (Chris Haddock, 2006–07) and *Human Cargo* (Linda Svendsen and Brian McKeown, 2004), found grateful audiences. Three early television movies with First Nations themes deserve attention: *Sister Balonika* (Philip Keatley, 1969), *I Heard the Owl Call My Name* (Daryl Duke, 1973) and *Dreamspeaker* (Claude Jutra, 1976).

Vancouver's independent film-makers have a reputation for iconoclasm, innovation and resistance. Canada's first experimental film, *And-* (1941), was made

**By the 1920s, Vancouver was being marketed as the 'Film Capital of the British Empire', a claim promoters hoped would be underwritten by the 1926 British quota legislation.**

in Vancouver by Dorothy Fowler and Margaret Roberts. Stanley Fox and Peter Varley's poetic, impressionistic 'city symphony', *In the Daytime* (1949), won Honorable Mention at the 1949 Canadian Film Awards. Vancouver's experimental film-makers gained an international reputation during the 1960s and 1970s for structuralist, poetic cinema. A number of radically independent features addressed the spiritual malaise of urban culture. Robert Altman's *McCabe & Mrs. Miller* (1971) gave a generation of Vancouver film actors their start in the movies, and the patriarchal counterculture was skewered in Sylvia Spring's *Madeleine Is ...* (1971), the first dramatic feature in Canada written and directed by a woman. Dennis Wheeler's *POTLATCH ... a strict law bids us dance* (1975), a collaboration with the U'Mista Society in Alert Bay, combined fiction and documentary to address the seizure of potlatch regalia by the Dominion government in 1921. Zale Dalen's *Skip Tracer* (1977), a dark comedy about the city's sordid netherworld, was the first feature film to cast Vancouver as a character.

Thanks to encouraging federal and provincial policies in the 1980s and 1990s, film and television production in Vancouver increased and memorable documentaries and features were produced. Phillip Borsos's *The Grey Fox* (1982) and Sandy Wilson's *My American Cousin* (1985) made the largest impact with their stories set in motion by the sudden arrival of charismatic, transgressive Americans. Madcap Vancouver animators began appearing at international festivals, screenwriters bloomed, some talent fled south, some returned, and First Nations film-makers, actors and video artists began to represent their own histories, communities and lives in the city.

Works of consequence continue to be produced, revealing a fiercely independent spirit. The cinema of this cosmopolitan city is as diverse as its population. William Vince, who died in 2008, produced memorable films including *Capote* (2005) and *The Imaginarium of Dr Parnassus* (2009). The most successful grassroots film made in Vancouver – and Canada – in the last decade is surely *The Corporation* (2003), directed by Mark Achbar and Jennifer Abbott.

Vancouver's achievement is impressive. Collectively, its films reflect the diversity, the hope, and the rapidly changing, often troubled visions of a city coming of age in the twenty-first century. Please stay tuned. ✢

# THOUGHTS ON MAKING PLACES

Text by
KAMALA
TODD

*Hollywood North and the Indigenous City*

**EVERY PLACE HAS A LANGUAGE.** The land, with its own unique mix of plants, water and beings, speaks its own tongue. At the heart of indigenous teachings is the understanding that we must live *within* those land narratives and ecological matrixes. For millennia, indigenous people have written their own stories and meanings onto the land; their language and culture symbiotically interrelated with the land. How visible are those stories in our North American towns and cities?

With the colonial history of seizure and erasure, a lot has been dug up and paved over. In the rapacious rush to possess and settle the land, the European newcomers called the land empty, free for the taking. Land and resources were treated as commodities, void of pre-existing laws, cultural meanings or spiritual value – and carved into sprawling grids of private property.

Appointing themselves authors of the 'new world', the newcomers wrote indigenous people out of the story, inscribing their own narratives onto the remade land. Indigenous people have been pushed to the margins of their (urbanized) territories, their continuity and sovereignty widely unrecognized.

This is definitely the case in Vancouver, a city whose urban landscape developed very quickly. I was born and raised here – a Métis-Cree in Coast Salish territory. Hunq'umin'um is the language of the local people, such as the Musqueam and Tsleil-Waututh, who have always lived here. Their language and stories about places, events and elements are as much a part of Vancouver as cedar, salmon, salal and eagle. But few people know this. I have grown up surrounded by the mythologies and erasures of the dominant culture, the misperception that the city is a young, non-native place built by white men. As a plaque at Hastings Street reads: 'Here stood Hamilton, first land commissioner […] 1885. In the silent solitude of the primeval forest he drove a wooden stake in the earth and commenced to measure an empty land into the streets of Vancouver.'

The 'milltown to metropolis' image of Vancouver stages the city as a shiny, young Lotus Land – one of the world's most liveable cities. 'A shining city of towers and islands, surrounded by beaches and backed by snow-capped mountains, Vancouver is a young city with one ear tuned to the call of the wild and the other to the future' ('Living in Vancouver' BBC.com, May 2011)

Vancouver *is* beautiful and dazzling. But this is not a young city. Nor is this a British-city-turned-multicultural, as some narratives claim. Like all

North American cities, Vancouver is, what I call, an Indigenous City. But indigenous storyscapes are not clearly visible in Vancouver's landscape or narratives. In fact, Vancouver's relatively generic urbanity is what lends itself to being regularly used by Hollywood to portray Anywhere, USA.

As the fourth largest film and television production centre in North America, Vancouver is used to being on camera – but not cast as itself. Vancouver is highly prized as the city that can stand in for any place, a land upon which film-makers can write their imaginations. There is no following of protocols, no inclusion of indigenous people in the representations of their lands. City Hall gives out the permits.

What role does Hollywood play in erasing the language and local cultures of the places featured in its films? What does the frequent staging of Vancouver tell us about the ongoing assumptions that this land is free for the taking – or at least for the remaking?

Hollywood is a powerful place maker, writing its own narratives and geographies onto the land. As with colonialism, the remade land is treated as empty, malleable, even storyless – a commodity to consume, assimilate and write your dreams upon. Locals are removed and actors become the new citizens. Places are decontextualized, separated from their stories, culture, meanings.

**I have grown up surrounded by the mythologies and erasures of the dominant culture, the misperception that the city is a young, non-native place built by white men.**

In making Vancouver's spaces stand in for other, non-Coast Salish cities, Hollywood reinforces the non-Native image of Vancouver. Take the Downtown Eastside (DTES) for example, an inner city neighbourhood with a large Aboriginal population. If the script calls for a 'gritty' urban locale, the DTES is usually cast. While this neighbourhood is rich with culture, history and struggles, the stories of the actual DTES community are effaced. Local people do not have a voice in how their neighbourhood is framed/used. And so, people can watch a Hollywood icon speeding through the streets of the DTES and never learn about the culture of this place. They won't learn, for example, of the ongoing tragedies of missing and murdered women who mostly came from this neighbourhood. They too will be written out of the story.

Is it okay to shroud the stories of a place to tell a different story? Do we as film-makers have an obligation to represent a place truthfully? Colonialism, globalization and other forces of western capitalism see a barrier-free world open to free enterprise. Seemingly there is no problem with the visual use of the most suitable, most economical lands to make profitable films. But what are the consequences of erasure?

As a film-maker, my own work focuses on sharing Aboriginal stories of Vancouver, on undoing the erasures. Many local Aboriginal film-makers are working to give voice to the land, to the people of the land. While Hollywood is all about stripping away local culture, indigenous people are working to 'put their face back on their traditional territory' (Leah George-Wilson, Tsleil-Waututh Nation), and to once again have a voice in their (urbanized) territories. How to reinscribe the urban as indigenous? The surface of the city may not obviously reflect the indigenous cultures of those lands, but those cultures are always there. Indigenous people are part of the city and urban culture. So, really, it's also up to the viewer to learn the stories of the land – and to begin to see the mountains, parks and urbanized spaces, as indigenous. As Musqueam weaver Debra Sparrow has said: 'Some people say that there are no signs on the mountaintops, that it is not written anywhere that this is First Nations land. Anywhere you open the earth there is evidence. It is written in the earth.'

Will the language of the land once again be visible? ✤

# VANCOUVER

*maps are only to be taken as approximates*

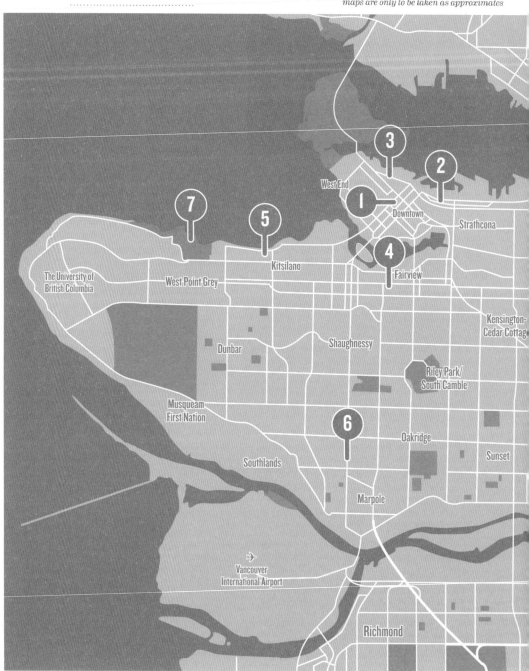

# VANCOUVER LOCATIONS
## SCENES 1-7

# POLICING THE PLAINS (1927)

LOCATION *Provincial Court House, 800 West Georgia Street, now Vancouver Art Gallery, 750 Hornby Street*

**A. D. 'COWBOY' KEAN'S** 1927 epic about the founding and early years of the North-West Mounted Police is by all accounts the first Canadian-made film shot in Vancouver. Tragically, after playing for only one week in Toronto in December 1927, the film was never seen again – lost into the ether of history. *Policing the Plains*'s opening scene was shot on the steps of what was then British Columbia's Provincial Court House. This building has undergone a number of changes over the years, and accordingly has served a number of purposes. Built in 1906, the building was initially the Provincial Court House, and as such conveyed a sense of law and order, subtly (or not so subtly) stressing an association – through its neoclassical architecture – with Ancient Rome. Yet in 1983, the building became the home for the Vancouver Art Gallery, and its connotations for subsequent generations were more directly linked with art and culture, albeit of the officially sanctioned variety. Most recently, in the fall of 2011, the space has been associated with public protest and dissent, as its outdoor grounds were the location of the global Occupy movement's Vancouver site. For Kean, who shot this scene in May 1924 when it still functioned as a courthouse, it was clearly the imposing sense of strength and justice, and the association with the British Empire (further emphasized by the inclusion of Margaret Lougheed as Lady Britannia) that was the motivating factor for its selection as a backdrop. Although much of the remainder of the film was shot throughout the British Columbian and Albertan countryside, these initial images are among the very first glimpses of urban Vancouver in fictional, feature-length cinema.

Photo © Andy Ji

*Directed by Arthur David Kean*
**Scene description: North-West Mounted Police pose with Lady Britannia**
**Timecode for scene: Unknown**

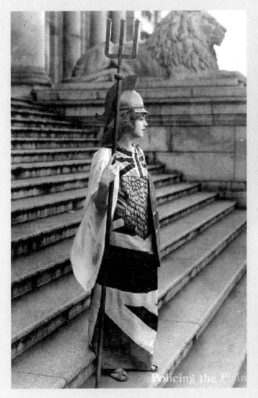

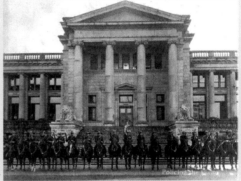

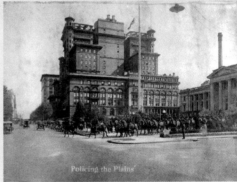

# SKIDROW (1956)

LOCATION *Abrams Block, 212 Carrall Street*

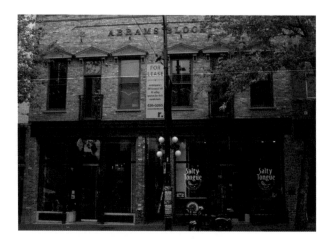

**ALLAN KING'S RELENTLESSLY BLEAK** *Skidrow* starts with a shot of a man collecting bottles from garbage bins, and immediately establishes its tone, a unique blend of poetic, didactic and matter-of-fact. Several skid row inhabitants are followed through their activities from sunrise to sunset, a time span very typical for the so-called city symphonies. In a way, *Skidrow* is a subversion of a city symphony: while certain edges are glossed over (Joe Skidrow – a generic skid row inhabitant – is usually shown to have some criminal past, and differentiated from poorer 'old-timers', who are self sufficient), others pierce directly through the sheen of the city. This decorum completely breaks down by the end of the film: four skid row inhabitants head to a rented room to conclude their day with a nightcap of a gallon of port. This scene illustrates the multifaceted tone of the film particularly well: the men are shown drinking, while a contrapuntal score progresses from a kind of slowed-down ragtime to a sequence of discordant chords. Similarly, the men falling over and getting up border on slapstick, yet the tone of the narration is very sombre. Eventually, the rented room can accommodate only one; thus, one of the unlucky men is shown stumbling out of the room and into an alley. Any ambiguity in the tone is completely dispelled in the final shot of the man falling over to sleep in a doorway, with the narrator stating 'the meek shall inherit the earth. Six feet of it.' ➠*Laurynas Navidauskas*

Photo © Barbie Xiao (wikimedia commons)

*Directed by Allan King*
**Scene description: Skid row men finish their night drinking in a hotel room**
**Timecode for scene: 0:32:42 – 0:37:28**

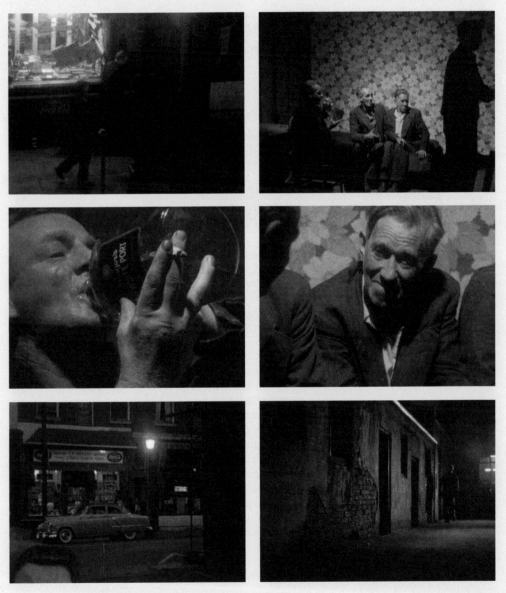

Images © 1956 CBC Vancouver

# THE BITTER ASH (1963)

LOCATION *1325 West Pender Street, now 555 Jervis Street*

**PRETENTIOUS WOULD-BE PLAYWRIGHT** Colin toils at an eternally unfinished treatise on violence while his wife Laurie is caught in a proto-feminist bind as both progressive breadwinner and traditional housewife. Colin is convinced he needs to get out of this 'backwater' to make it big, and the rail yard across from his dilapidated Edwardian rental house acts as both siren call to other worlds and dismal reminder of Vancouver's position as end of the line. In a company town founded as the Canadian Pacific Railway's terminus, houses like these were once built for labourers but would eventually be commercialized or transformed into heritage properties for an upper class; this one was demolished and replaced by a residential high-rise. Short on cash, the couple throws a rent party depicted in an extended scene that remains one of the signature documents of Vancouver's emerging counterculture. And here a dissatisfied Laurie ends up in bed with Des, a caustic soul embittered by his own domestic situation and a factory job soon to become obsolete. Fists fly between Colin and Des on the front landing, a battle between the dead-end reality of the working class and idealized dreams of another life elsewhere. Set to the industrial sounds of the neighbouring trains, the scene is a potent audiovisual representation of the isolationist angst typical of Vancouver as both Terminal City and transnational intersection. Bloodied and humiliated, Colin endures Laurie's taunt: 'There's violence for you; now you can really write about it,' a comment just as pertinent to Vancouver's own need of a reality check during this transitional phase of its self-identification. **↬Randolph Jordan**

Photo © Maia Joseph

Directed by Larry Kent
Scene description: Fight on the landing of Colin and Laurie's house
Timecode for scene: 1:17:21 – 1:18:48

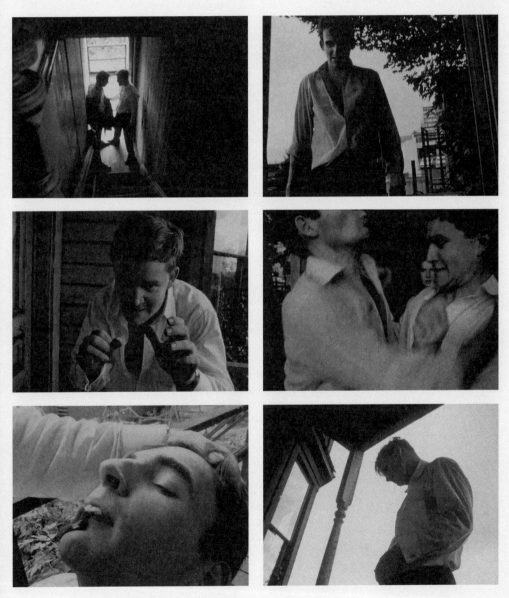

# SWEET SUBSTITUTE (1964)

LOCATION *900-block West Broadway*

**THE DRAMATIC CORE OF** *Sweet Substitute* is the tension between high-school student Tom's potential and his overreaching desire. He's smart enough to get a college scholarship, *if* he stays out of trouble. He has a good friend in his study-partner Kathy – but his passions demand more. At night, he and buddy Bill cruise Vancouver's neon-lit entertainment strips, hoping to pick up women. Although Vancouver plays itself here, it's a generic urban prison for a smart, good-looking boy with ambition. In this scene, Tom and Bill posture, brag, and try to bluster a car salesman into letting them test-cruise a fancy convertible. They pretend to drive the parked car, like children, thinking no further ahead than the girls they might impress. The salesman, who lives off such fantasies, tries to lure them towards something they can afford. They cling to their dream and he finally shoos them off. Then along comes Al, the boys' role model: a boor with a car, old enough to buy booze and savvy enough to line up willing girls – not just for himself, but for his in-crowd as well. The boys drive off together to get beer. In the ugly landscape, it's nothing but drab clutter to both horizons. Maybe there's something just beyond – but to get there requires wheels. Tom and Bill fall under the spell of the first jerk to come along who offers a taste of freedom and power. **➻Flick Harrison**

Photo © Flick Harrison

*Directed by Larry Kent*
Scene description: Tom and Bill fantasize about buying a fancy car
Timecode for scene: 0:30:20 – 0:33:15

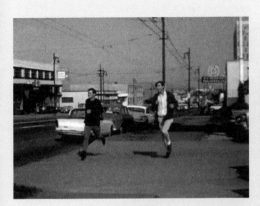
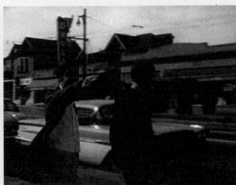

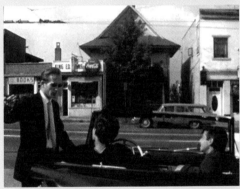
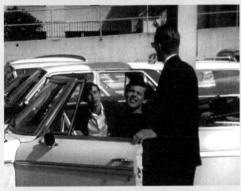

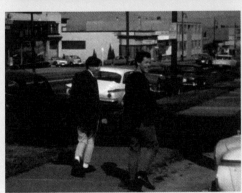
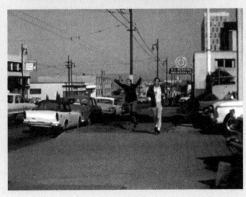

Images © 1964 Larry Kent Productions

# THAT COLD DAY IN THE PARK (1969)

LOCATION *Tatlow Park, Point Grey Road at Macdonald Street*

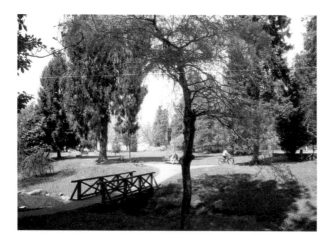

**ROBERT ALTMAN WANTED TO FILM** his adaptation of Richard Miles's novel of emotional suppression and isolation in chilly and reserved England; he settled for the next best thing, the Empire's damp and far-flung Vancouver outpost. Frances Austen (Sandy Dennis) is in her thirties and lives alone on the fringe of Point Grey's retiring ex-pat colonial administration. In her labyrinthine apartment of floral wallpaper adorned with paintings of the Midlands and portraits of the Queen she entertains guests of her parents' generation and rebuffs suitors 25 years her senior. She spies a young man (Michael Burns) sitting in the rain in Tatlow Park and invites him in: a soggy, blonde kitten for her to bathe (naughty bits discreetly ensconced behind a towel), feed, clothe and put up for the night – locking the door from the hallway side, for safe keeping. Tatlow is a park of the highly engineered 'tranquil English' variety: tennis courts, carefully manicured lawns, little bridges crossing the trickling ghost of Tatlow Creek. But even with these highly proscribed elements, the trees impress – the slowly swaying sequoias and weeping willows that on a sunny Sunday morning inspired Bill Reid to voice *The Spirit of Haida Gwaii* (1991) at a single sitting. A social/natural intersection that brings together Frances's tightly ordered old world with the rather more anarchic life of a silent, nameless, enigmatic man-child – to disastrous effect. **➡️ Elvy Del Bianco**

Photo © Andy Ji

*Directed by Robert Altman*
*Scene description: Lonely, delusional woman befriends young drifter in Tatlow Park*
*Timecode for scene: 0:03:06 – 0:09:57*

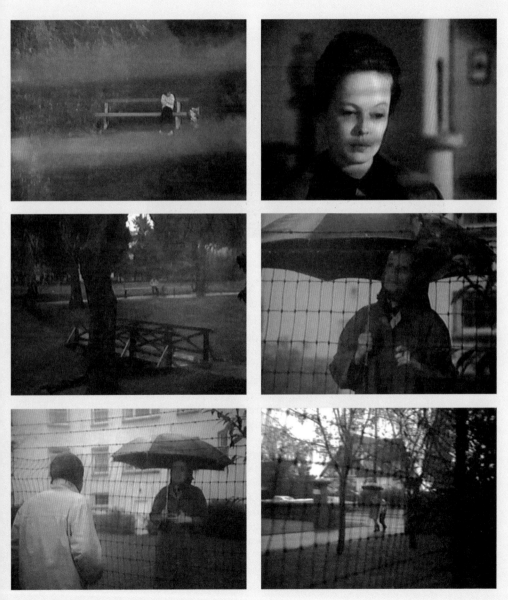

# CARNAL KNOWLEDGE (1971)

LOCATION *Shannon Mews, 7131 Granville Street*

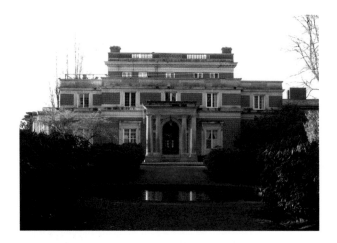

**MIKE NICHOLS'S DIRECTION** and Jules Feiffer's screenplay bluntly examine sex and relationships, through the empty sex fantasies of Jonathan (Jack Nicholson) and the intellectual desert and fear of the physical experienced by Sandy (Art Garfunkle). Vancouver's 'Shannon Mews' stands in for Massachusetts's Amherst College. Built by sugar baron Ben Rogers in the 1920s, the estate's Beaux Arts style visually suggests Amherst's Main Quad. Opening scene: Interior Amherst College Student Mixer – Late 1940's; in a flowing hand-held master, we follow Susan (Candice Bergen) as she walks out of darkness and enters the college. Susan briefly explores two rooms filled with young couples and singles, eventually passing Jonathan and Sandy. Susan keeps walking, but the camera stops on the two men. They access Susan as a possible sexual conquest, an exchange that ends with Jonathan 'giving' her to Sandy. This first, unhurried master establishes the narrative's central questions and how we will view the struggle to resolve them in a manner that belies how high the stakes really are. Once Sandy does manage to speak to Susan (an action she initiates), the scene unfolds in mainly wide, complimentary masters, establishing visually the love triangle that is to come, as Jonathan watches Sandy and Susan from a distance. The dialogue is equally smooth, shifting from frat-boy crass (Jonathan and Sandy) to sharp and witty (Susan and Sandy). The post-war period, Ivy League atmosphere and a certain youthful/sexual expectation is established beautifully.
➻ *David Hauka*

Photo © David Hauka

*Directed by Mike Nichols*
**Scene description: A love triangle emerges as Jonathan and Sandy meet Susan**
**Timecode for scene: 0:02:55 – 0:08:15**

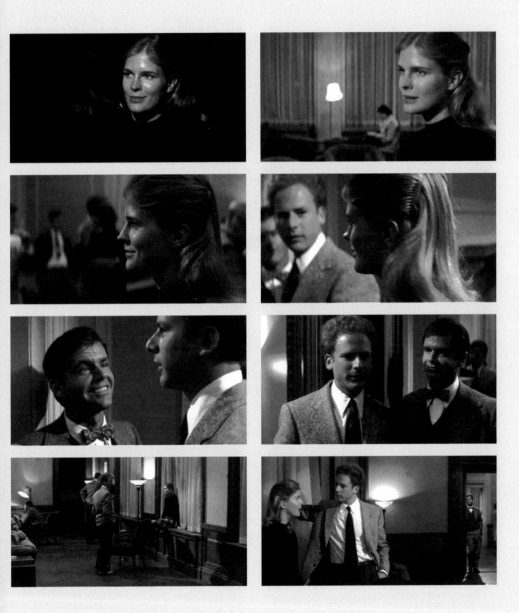

# WOLFPEN PRINCIPLE (1973)

LOCATION *The Jericho Sailing Center, 1300 Discovery Street*

**HENRY (VLADIMÍR VALENTA),** manager of a seedy Vancouver cinema, equates this job with his time as prisoner in a Nazi camp during World War II, as such disrupting the notion of white privilege in a city known for its European majority. He pays nightly visits to the arctic wolves of the Stanley Park Zoo, howling with them in empathy with the imposed order that liberates them from the illusion of freedom in the modern capitalist world. But Native drifter, 'John A. MacDonald Smith' (Lawrence Brown), believes these animals were once denizens of his ancestral village and eventually convinces Henry that they should be freed. Upon attempting the liberation, however, they discover that the wolves are content with their lot, uninterested in walking out of their prison as Henry once did. The wolves thus act as metaphorical embodiment of Vancouverites living in an urban cage disguised as natural paradise for dispossessed aboriginal people and willing immigrants alike. Jailed after the zoo affair, Henry contemplates Vancouver's signature view of mountains and sea framed by the bars of his cell, rendering Vancouver's natural wonder a commodity for captives of the city. At the film's conclusion we are told that 'the cost to the wolves caged is the price paid by their keepers', the definition of the titular 'wolfpen principle'. Yet Henry's position subverts easy readings of this principle as critique of colonialist hegemony; instead we are prompted to question the role of self-imposed captivity through willing ignorance of the tension between modern society and a past represented by the city's spectacular natural setting.
**➻ Randolph Jordan**

Photo © Andy Ji

*Directed by Jack Darcus*
*Scene description: Henry contemplates urban captivity from within a waterside jailhouse*
*Timecode for scene: 1:03:29 – 1:07:04*

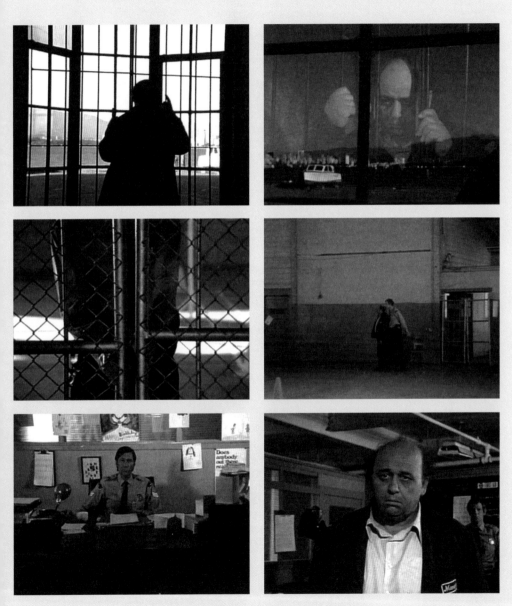

Images © 1973 CFDC

# JAMES CLAVELL's
# THE SWEET AND THE BITTER

Text by
MICHAEL
TURNER

**AFTER THE PUBLICATION OF** his bestselling first novel, *King Rat* (1962), Australian-born screenwriter James Clavell purchased a home at 7165 Cliff Road in the municipality of West Vancouver, British Columbia (BC), where he and his family would live when not in Los Angeles. It was at Cliff Road that Clavell began his 'Asian saga' novels (*Tai-Pan* [1966], *Shogun* [1975], *Noble House* [1981]), as well as screenplays to films such as *633 Squadron* (1964) and *To Sir, With Love* (1966), which he also directed. A lesser-known film is *The Sweet and the Bitter*.

Once settled, Clavell set out to explore the Vancouver area – its natural beauty but also its history. A story he was familiar with, as a soldier stationed in the South Pacific during World War II, was the relocation and internment of Vancouver's Japanese Canadian population following the invasion of Pearl Harbour. Only after his arrival did he learn that Japanese Canadian property confiscated by federal authorities was sold at auctions and kept as general revenue. This last revelation would provide Clavell his hook. In short order, he wrote a script, secured financing and prepared to direct

his first feature film.

*The Sweet and the Bitter* is the story of a young Japanese woman who comes to Vancouver as a mail-order bride with the intent of ditching her Japanese fisherman husband and seducing – then ruining – the son of a Scottish salmon canner who profited from the confiscation of her unknown father's fishing boat. Bad intentions give way to good ones, and the woman and the canner's son fall in love. As with the novels of Clavell's idol, Ayn Rand, coincidence abounds: the Japanese husband turns out to be the young woman's father, and a sub-story that suggests the young woman might in fact be the product of the canner's wartime affair with a geisha is left flapping.

Although completed in the summer of 1962, *The Sweet and the Bitter* sat in limbo due to legal problems between the recently-built Panorama Studios and Commonwealth Film Productions Ltd, a millionaire-backed government-subsidized outfit designed to kick-start a local film industry. When the film was released, in 1967, it had little publicity and received few screenings. Reviews ran the gamut, from bemused to cruel. The film (shot in black and white) was a technical disaster,

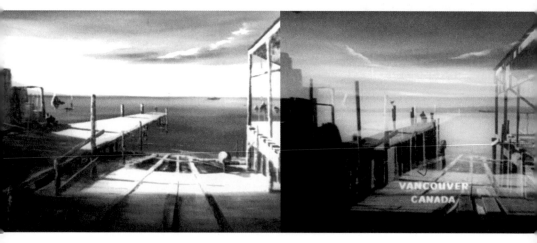

marred by inconsistent lighting, inexplicable edits and wooden acting. Despite Clavell's effort to address Vancouver's hidden history of Japanese Canadian internment, lack of redress and racism, the film is little more than an essentialist recovery narrative that ends with the two lovers literally sailing off into the sunset.

But for all its failures, *The Sweet and the Bitter* is an important document that both captures the city in time and space and anticipates the city to come. When the Clavells arrived at Cliff Road, BC's economic base was primary resource extraction. Forestry, mining and fishing were the main industries, and all were present in the Vancouver area: a False Creek beehive burner incinerated sawmill detritus 24/7, enveloping the city in a thin grey haze; the Vancouver Stock Exchange specialized in regionally-sourced metals and spewed fast moving men in suits; and dotting the shores were salmon canneries, like the one in *The Sweet and the Bitter*.

West Vancouver's Great Northern Cannery, with its waterfront view of Burrard Inlet and Point Grey, seems absurd today given the multi-million dollar homes that now rise from the north shore like a massive glass staircase. Yet it is here that the young Japanese woman is taken to meet her betrothed. He has arranged for her a fish-washing job, at which she fails. Whether this failure is due to her delicate condition, or an acute case of social-class panic, is uncertain. What *is* certain is that most of the cannery workers are First Nations (Salish) women. To his credit, Clavell allows for extended documentary-style shots of these workers, enough to suggest that the ethnic and gender stratification

of canneries (where First Nations women washed fish and Japanese men were fishers) was a reality on the BC coast.

The cannery is also the site of the film's opening shot, a credit sequence that involves a number of unremarkable, if surrealistic, paintings that culminate in an oil-on-canvas cannery dock dissolving into its filmic representation – the words VANCOUVER, CANADA appearing on-screen for the first time in feature-film history. What might seem like a clever bit of titling is, to this viewer, the foretelling of Vancouver's economic transition from natural resources (in this instance, a commercial fishery) to tertiary industries, the most notable being film and television production. Another parallel relates to the city's symbolic culture: where painting was once the dominant artistic medium, today it is photo-based work, as evidenced by the international presence of visual artists such as Stan Douglas, Rodney Graham and Jeff Wall.

West Vancouver has always been the seat of modernity in the Vancouver area, from the site of the first commercial gallery dedicated to contemporary modern art (the New Design Gallery in 1955), to a modern/rustic architecture made famous by Arthur Erickson and Ron Thom. West Van is also where the new money went after World War II, where doctors and lawyers born of immigrant parents built homes because no one in old-money Shaughnessy would talk to them. Indeed, whereas the old money decorated their homes with antiques from the Edwardian era, West Van's nouveau riche purchased works by then-emerging artists such as Robert Smithson, Robert Rauschenberg and Andy Warhol.

If Paris is the most filmed city in cinema, Vancouver is the most photographed in contemporary art. Regarding the subject of these photographs, they include landscapes that range from 'defeatured' urban-suburban interfaces (Wall) to instances of utopian failure (Douglas). The construction of these photos tells another story, where a subject is photographed numerous times, occasionally at different locations, and brought together to form a single image. Wall refers to this as the 'cinematographic', while for Douglas it is simply montage. Either way, the transition at the opening of *The Sweet and the Bitter* alludes to both a material and a symbolic shift in Vancouver's history, and in doing so provides a glimpse into what is now, fifty years later, its present. ✢

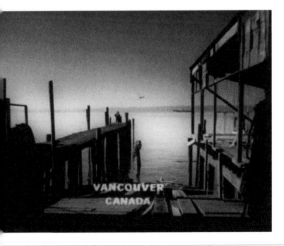

## LOCATIONS MAP

# VANCOUVER

*maps are only to be taken as approximates*

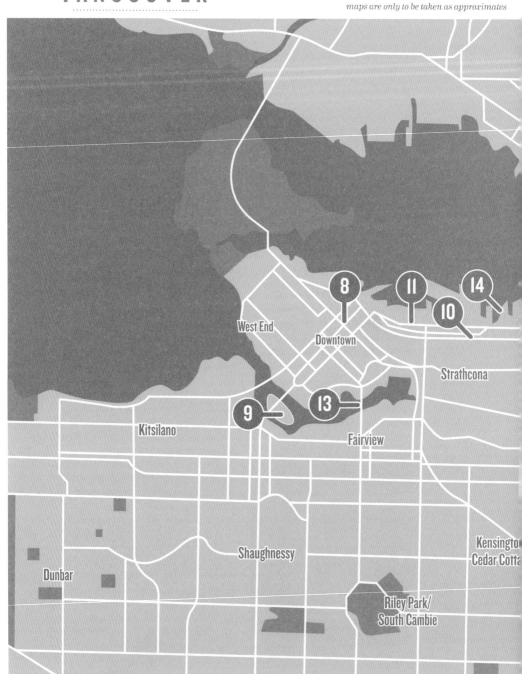

West End

Downtown

Strathcona

Kitsilano

Fairview

Shaughnessy

Kensington
Cedar Cotta

Dunbar

Riley Park/
South Cambie

# VANCOUVER LOCATIONS
## SCENES 8-14

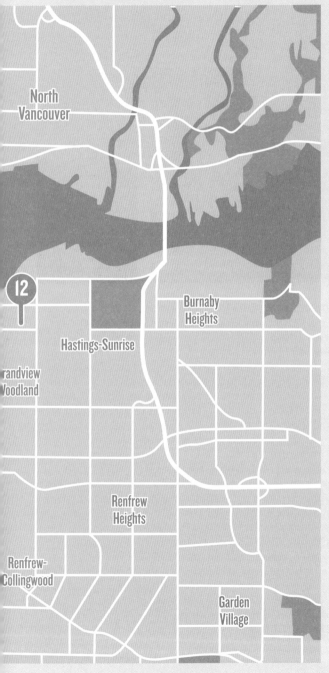

8.
RUSSIAN ROULETTE (1975)
Hotel Vancouver,
900 West Georgia Street
*page 30*

9.
SKIP TRACER (1977)
Intersection of Johnston Street and
Cartwright Street, Granville Island
*page 32*

10.
OUT OF THE BLUE (1980)
The Viking Hall,
828 East Hastings Street
*page 34*

11.
THE CHANGELING (1980)
Hotel Europe, 43 Powell Street
*page 36*

12.
STAR 80 (1983)
Dairy Queen,
2109 East Hastings Street
*page 38*

13.
SWINGSPAN (1986)
Cambie Street bridge, False Creek
(demolished 1985)
*page 40*

14.
STAKEOUT (1987)
Marine View Café and
Campbell Avenue Fish Dock
(demolished 1989)
*page 42*

# RUSSIAN ROULETTE (1975)

*Hotel Vancouver, 900 West Georgia Street*

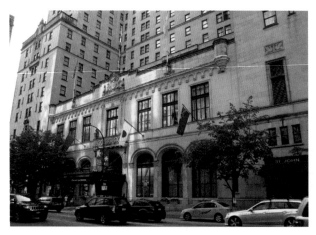

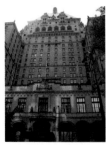

**DISGRACED FOR PUNCHING HIS** commanding officer in the face, Royal Canadian Mounted Police (RCMP) Cpl Timothy Shaver (George Segal) is offered a clean slate in exchange for a little cloak-and-dagger job: just the brief and illegal detention of a dissident to keep things nice and quiet during the upcoming state visit of Soviet Premier Alexei Kosygin. Soon Shaver is ducking and dodging CIA and KGB operatives, a hired Detroit mafioso, and a duplicitous and greasy Canadian bureaucrat to foil an assassination. *Russian Roulette* plays like a parboiled travelogue of a grey and gritty Vancouver winter: sotto voce confrontations in Chinese restaurants, fist fights to the death on West Vancouver lawns, murder victims on Grouse Mountain. Seasonal music plays as the body count rises. It's Christmas celebrated at a morgue with cigarettes and Styrofoam cups. Kosygin's motorcade and a helicopter conveying the assassin – doped-up dupe laden with explosives – converge on the Hotel Vancouver, Mark III: the Canadian National Railway's 'châteauesque' fantasy of griffins, gargoyles and oxidized copper. Not quite as beautiful as its previous Renaissance revival incarnation or its since destroyed neighbour, the Georgia Medical Building, visible here in glimpses. Still, a jewel in the downtown crown, where the King of Swing held court at the Panorama Roof Ballroom and the Mother Corp moved the public's airwaves from an art deco sound stage on the mezzanine. Shaver claws his way across the precipitously sloped mansard roof, semi-automatic at the ready. From the pinnacle of the city's palatial redoubt, he surveys the plot unfolding below, takes aim and fires. **⇢Elvy Del Bianco**

Photos © Andy Ji

*Directed by Lou Lombardo*
*Scene description: Rogue RCMP officer foils assassination from the Hotel Vancouver roof*
*Timecode for scene: 1:20:01 – 1:27:22*

Images © 1975 Bulldog and Incorporated Television Company (ITC)

# SKIP TRACER (1977)

LOCATION *Intersection of Johnston Street and Cartwright Street, Granville Island*

**IT'S 1976 ON GRANVILLE ISLAND** and debt collector John Collins (David Petersen) chases down client Steve (Steve Miller) at his factory job. In the years following the film's release this industrial core of the city has morphed into Vancouver's most popular public marketplace at the heart of an up-scale residential development. The transformation of Granville Island is the signature of Vancouver's dash to attain world-class status through the touristic commoditization of the city's industrial origins while pushing actual production out of view. Jobs like Steve's are now rare in the city, and here Collins reminds Vancouverites that the line between middle-class comfort and the skid row poverty caused by the evacuation of urban industry is articulated through the culture of debt. Collins traps Steve in a metal pipe and bangs on it repeatedly with a rod, enacting the noise pollution associated with development that would frame the noise abatement campaigns of this period. Steve escapes and climbs to the top of a yellow crane, imploring Collins to consider the costs of his chosen lifestyle – words the collector eventually takes to heart. Wearing a suit and set against the downtown office towers visible in the distance, Collins becomes the embodiment of the corporate drive of the city's development tempered by the appeals of local planners concerned with maintaining regional specificity. And so Steve's crane still stands on the island as part of the market's famous industrial kitsch, the ramifications of which remain as invisible to shoppers as the toxic waste lying at the bottom of the surrounding waters. **➻Randolph Jordan**

Photo © Sarah Banting

Directed by Zale Dalen
*Scene description: Collins visits client at Granville Island factory*
*Timecode for scene: 1:02:13 – 1:06:25*

# OUT OF THE BLUE (1980)

LOCATION *The Viking Hall, 828 East Hastings Street*

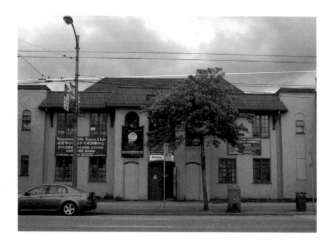

'**DISCO SUCKS. KILL ALL HIPPIES.** *Subvert normal,*' demands Cebe (Linda Manz). But what is subversive when dad is Dennis Hopper, at the end of a prison term for drunk driving his 18-wheeler into a school bus, mom (Sharon Farrell) uses heroin to settle her nerves, and Elvis has died? Teenaged Cebe is tiny and scarred – physically and otherwise; she's quick to curl-up with her teddy bear and suck her thumb. But she's angry and aggressive, flipping the bird, settling scores and dispatching lecherous cabdrivers with busted beer bottles. She's a clenched fist, pint-sized gesture of frustration. Dennis Hopper was two weeks into an acting gig on *Out of the Blue* when the genius maniac assumed the directorial reigns. He changed course: writing down Raymond Burr's star role, playing up the tension and sleaze, and carving a highway of emotional turmoil complete with its own roadhouse. The facility formerly known as the Viking Hall is one of many along East Hastings that have played host to everything from ex-pat working-class wedding receptions to table tennis clubs and – briefly in the late-1970s and 1980s – punk rock concerts. Hopper kept the real life punk extras outside in the cold for a dozen hours waiting for the Pointed Sticks and The Dishrags before opening the doors to the drunken crowd and filming the ensuing chaos. In the loud fast vortex is Cebe, on stage and hammering away at the drums – from out of the blue, a brief, brilliant flash of pure joy. **Elvy Del Bianco**

Photo © Andy Ji

*Directed by Dennis Hopper*
*Scene description: Troubled teen cuts loose*
*Timecode for scene: 0:31:42 – 0:36:26*

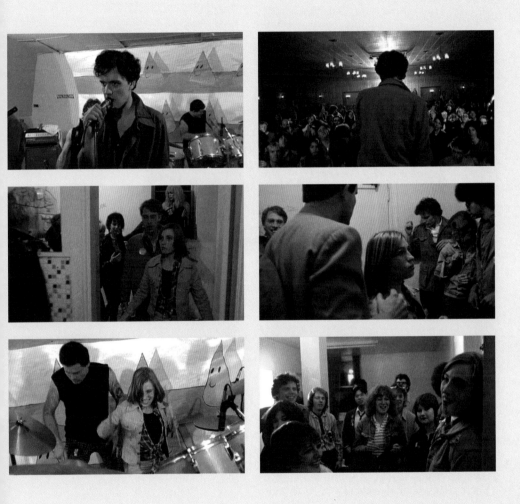

# THE CHANGELING (1980)

LOCATION *Hotel Europe, 43 Powell Street*

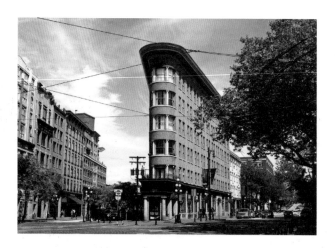

**OF ALL OF THE FILMS MADE** during Canada's infamous 'tax shelter' years (roughly 1975–82), Peter Medak's 1980 supernatural thriller *The Changeling* is among the few films whose reputation has emerged largely intact over the years. Widower John Russell (George C. Scott), while coping with the deaths of his wife and daughter, discovers that the mansion he has been leasing has a particularly mysterious past. The house in question, however, which serves as the film's central set piece and home to the unexplained occurrences, was in fact a composite of exteriors and studio-built sets. Russell's investigative work that drives the film's narrative is rooted at the Hotel Europe – doubling as the Seattle Historical Society – in Vancouver's historic Gastown district, and it is here that the city ultimately appears at its most distinctive. Built in 1908–09 in the flatiron style, the hotel is a central landmark, occupying a triangular lot in the heart of Gastown, the city's original downtown core. In the first of three scenes showcasing the Hotel Europe, an establishing shot situates the building in its neighbourhood context, with a quick cut to the building's rooftop patio where Russell discusses his early observations and suspicions about his new home with Claire Norman (Trish Van Devere, Scott's wife at the time), a member of the Historical Society. Curiously, we are not provided a full shot of the building's exterior until Russell's second visit (with equally curious little attention paid to masking the building's prominent 'Hotel Europe' sign). Fittingly, given the nature of the film, there have been a number of reported encounters with ghosts and spirits by the building's occupants over the years. ➡ **Peter Lester**

Photo © Maia Joseph

*Directed by Peter Medak*

*Scene description: Russell researches his mansion's mysterious past*

*Timecode for scene: 0:30:00 – 0:32:02 and 0:40:55 – 0:41:55*

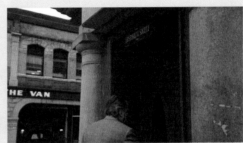

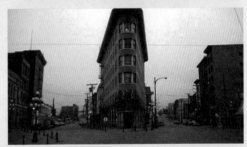
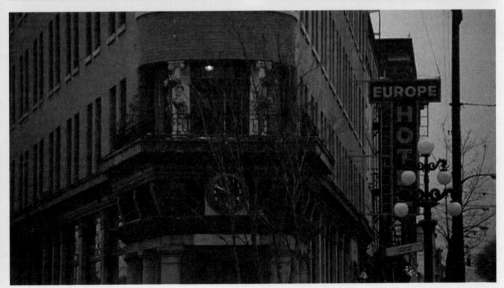

# STAR 80 (1983)

*Dairy Queen, 2109 East Hastings Street*

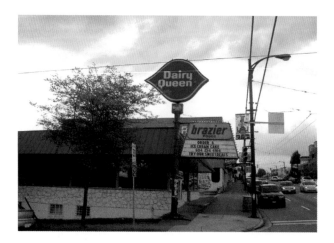

**BOB FOSSE'S VANCOUVER IS A DISTANT** suburb of Los Angeles, on the periphery of wealth and fame: a grey and gritty expanse of working-class neighbourhoods, strip joints and fast food outlets. Small-time hustler, pimp and full-time creep Paul Snider (Eric Roberts) discovers his path up the social ladder in wholesome, fresh faced, naive, *Playboy*-centrefold-ready girl-next-door, Dorothy Stratten (Mariel Hemmingway). Snider latches onto her at a Dairy Queen – specifically the DQ at 2109 East Hastings. The very same that the real life Dorothy Stratten worked during high school, on a low-rent strip of grocers and greasy spoons serving the modest needs of warehouse, factory and port workers to the north, and the Italian and Chinese tradesmen and their families resident to the south. Snider is with a woman – tall, blonde, an older version of Dorothy, a prototype suddenly rendered obsolete. They're both wearing fur coats, soaked by a temperate sub-monsoon. Rain bounces off the tarmac and Snider's dash-carpeted white Trans Am, disco-era Rod Stewart in the tape deck. Stratten is an exotic flower – 'something sweet, soft and white' – miraculously blooming in a desolate environment. Snider uproots her and vows to make them both famous. She moves quickly from soft-focused bush shots to schlock-fest bit parts to the creative and amorous attentions of an auteur. She breaks free of Snider's grasp, but not the range of his shotgun or the sordid and enduring infamy of the murder-suicide. A couple of kids from the sticks, making it big in LA. •➤ *Elvy Del Bianco*

Photo © Andy Ji

*Directed by Bob Fosse*
**Scene description:** *Pimp and hustler discovers his ticket to fame and fortune*
**Timecode for scene:** *0:09:40 – 0:10:29*

# SWINGSPAN (1986)

*Cambie Street bridge, False Creek (demolished 1985)*

**SWINGSPAN IS A 30-MINUTE DOCUMENTARY,** funded through the 1985 Centennial Projects programme (City of Vancouver). It follows the final days of the Cambie Street Bridge prior to its 1985 demolition, part of Vancouver's radical regeneration in the run-up to Expo '86. Shot on colour 16 mm film, the poetic-performative documentary follows the fictional Dirk (Tom Turnbull) as he researches the iconic bridge's history. The scene provides an 180º observational panorama of the city as it swings from past to future. With no commentary or music, the four-minute scene relies on the location-recorded sound of traffic, industry and bridge machinery. An establishing shot shows the bridge's north-to-south route up Cambie Street towards Vancouver City Hall, the tall Plaza 500 Hotel at Cambie and West 12th Avenue visible in the left of the frame. Dirk runs and leaps onto the bridge just as the barrier lowers and it begins its swing. He looks out over the rapidly changing False Creek landscape towards the emerging Expo '86 Plaza of Nations and Chinatown/Strathcona's social housing. He swings past Science World and in the background sees the Canadian National sign (now called Pacific Central) on the 1917 Beaux-Arts railway station on Main Street. As the bridge swings back into place, Dirk looks north, towards the Downtown Eastside. Finally, an unfinished BC Place Stadium swings in to view. As the bridge aligns with the Smithe Street off-ramp, Dirk sees the concrete foundations of the new bridge enclosed in scaffolding, surrounded by cranes. *Swingspan* won Best Film at the 1989 Northwest Film & Video Festival, Portland. •*Angela Piccini*

Photo © Diane Burgess

*Directed by Bruno Lazaro Pacheco*
**Scene description: Cambie Street Bridge's final swing between past and future**
**Timecode for scene: 0:04:40 – 0:08:57**

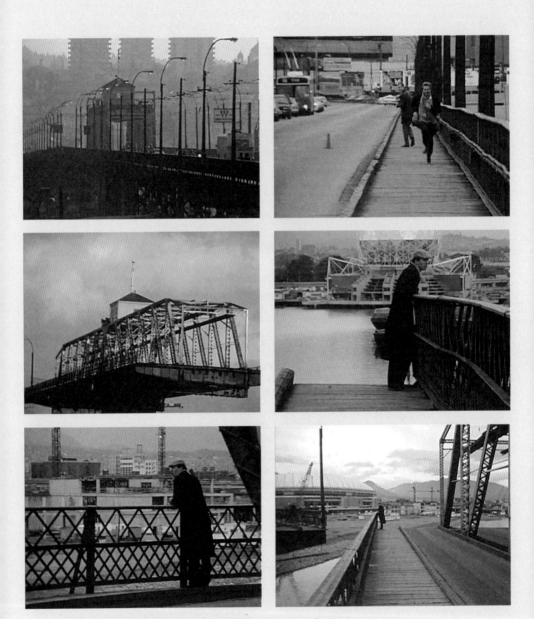

# STAKEOUT (1987)

LOCATION

*Marine View Café and Campbell Avenue Fish Dock (demolished 1989)*

**STAKEOUT WAS ONE OF THE FIRST** Hollywood films shot in Vancouver. In this scene, audiences are introduced to Chris Lecce (Richard Dreyfuss) and Bill Reimers (Emilio Estevez). Campbell Avenue Fish Dock serves to establish the pair's straight man/funny man cop-chemistry. A panning shot right across the interior of the Marine View Café settles on Lecce and Reimers, eating a classic Vancouver bacon and eggs with hash browns, brown toast and Tabasco. They spot their suspect and give chase, Vancouver's North Shore mountains framing the action. The industrial setting against the skyline performs a similar contrast to that between Estevez and Dreyfuss's characters, highlighted by a two-shot that positions their argument centrally against the Roger's Sugar Refinery. Hapless Lecce is caught by the suspect, whose criminal intent is signalled by a multicoloured faux-hawk and silver rings. After a short tussle, they fall into a vat of herring. While the suspect escapes, Lecce slides through a chute onto a conveyor belt, to the amusement of the Asian-Canadian cannery workers. Lecce spots the suspect running north along the wharf, the two Lions visible in the mountains to the left of the frame. Inevitably, Reimers commandeers a forklift at the other end of the dock. Lecce pulls out a gun and shoots. It ricochets off Reimers's forklift, he swerves and drives off the dock into Burrard Inlet. Putting aside the bickering, Lecce forgets the suspect and jumps in to save Reimers. The location was demolished two years after the film was released and this scene serves as a unique record of historic fisheries, including Reliance, Ocean and Murray's. **•➤Angela Piccini**

Photo © Dennis Ha

*Directed by John Badham*

**Scene description:** *Lecce and Reimers establish cop partnership.*

*Timecode for scene: 0:08:10 – 0:13:30*

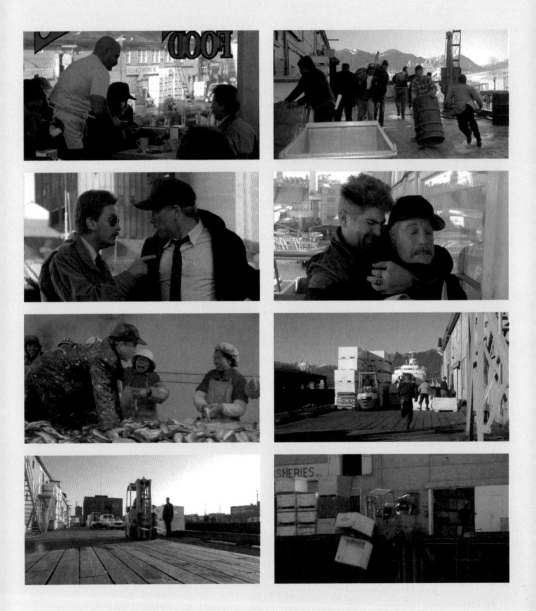

# VANCOUVER IS...

*Defining the City in Sylvia Spring's* Madeleine Is ... *(1971)*

Text by
RANDOLPH
JORDAN

**BEST KNOWN AS THE FIRST** narrative feature to be directed by a woman in Canada, Sylvia Spring's *Madeleine Is* ... should also be recognized as one of the best documents of Vancouver in the history of fiction film, unusually sophisticated in dealing with urban issues as pertinent today as they were in the 1970s. Here we find Madeleine (Nicola Lipman) recently transplanted from Quebec and eager to explore the social experiments for which the west coast metropolis had become famous. It was shot at the peak of the hippie movement fuelled by trans-provincial migration, a time rife with anti-counterculture sentiment when loitering laws were used to bully transient youth on downtown streets. As we follow her journey of self-discovery, Madeleine is prompted to reflect upon the politics of land-use in a city preparing for what would become a 30-year urban design plan that has been lauded the world over while failing to address crucial issues of street poverty. The film thus engages with the realities of Vancouver as an urban

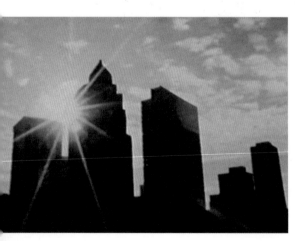

centre on the forefront of questions about the state of North American cities in the last third of the twentieth century. And in tying region-specific themes to extensive location shooting, the film stands apart from typical Vancouver productions that, whether foreign or domestic, tend to be less invested in engaging with the city than in making use of its resources for purely aesthetic or functional purposes.

Madeleine shares her loft in the Downtown Eastside with self-styled radical boyfriend Toro (John Juliani). With the iconic lighted 'W' of the Woodward's complex visible just behind the apartment building, they look out across the Canadian Pacific Rail yard set against the waters of Burrard Inlet and the North Shore mountains. Toro is associated with industry, fascinated by the coupling trains that fuel his sexual desire as he calls Madeleine's attention to their sound outside their bedroom window. But Madeleine is associated with nature, preferring the scenic backdrop and its implied quietude, her own fantasies of a dream boy always set by the water without a hint of civilization. When challenged by Toro on her escapist flights of fancy, Madeleine answers: 'at least my fantasies are innocent', pointing to his sexual quirks as evidence of corruption by the very system he wants to challenge. Their gender-stereotyped associations reflect utopian accounts of Vancouver's harmony between civilization and the wilderness, but ultimately the film breaks these characterizations down. Toro has been using Madeleine's loft as part of his plan to organize the transient members of Vancouver's young hippie community into a vehicle for systemic change, ultimately seeking to leave the city and start fresh on one of the islands off the coast. Meanwhile Madeleine becomes increasingly entrenched in the street culture of

to increase cultural activity: for some a remedy for the DTES's decline; for others the feared herald of gentrification. In Woodward's atrium hangs Stan Douglas's mural Abbott & Cordova, 7 August 1971 (2008), a critique of the violent police break-up of a counter-culture protest that occurred months after Madeleine Is …was released. The film thus illustrates the importance of activist art to the area while foreshadowing the dispersal of hippie life that once challenged city by-laws to other neighbourhoods, and ultimately to the rural islands and interior.

The film charts Madeleine's shifting positions by way of strategic location shooting. There is a wealth of sequences shot downtown, treated with different stylistic approaches to capture a range of tonal qualities including: the calm of a morning yoga session across from the train yard; the bustle of a heavily trafficked commute to work; a free-jazz sprint through the neon night following a fight with Toro; a psychedelic meditation on the city's imposing architecture prior to a dream-therapy session; and a melancholy tour of the street life in sepia-toned stills as Madeleine begins her documentation project. As such the downtown core is presented as a heterogeneous space resisting easy categorization when set against the interstitial spaces of the beach or the remove of the Gulf Islands.

But perhaps the most significant location is the West End condo high-rise occupied by David (Wayne Specht), the corporate suit Madeleine befriends as the boy from her fantasies. David is emblematic of the rising professional class that would go on to claim the gentrified views of Vancouver's classic mountain backdrop in high-rises like these, increasingly encroaching upon the scenery for all those removed from the waterfront. But the film refuses essentialism, and it is David, not Toro, who recognizes Madeleine's talent for capturing the essence of downtown street life in her painting. While Madeleine doesn't end up choosing either man as partner, the film is provocative in allowing for David to be a positive influence in Madeleine's life, keeping any strict lines from being drawn between the various conflicting worlds that intersect in the film. It is this willingness to acknowledge overlapping claims to the city's spaces that speaks most to Madeleine's character, the film's title leaving her self-definition open to situation-specific fluctuation that could just as easily be applied to the city itself. Vancouver is … ✚

an older generation who are homeless by dint of the city's changing relationship to industry rather than by privileged choice. Toro rejects these older social problems as unsalvageable. While he seeks to escape, Madeleine engages with her new urban home, reversing the relationship between their character psychologies and associated settings.

Madeleine begins to paint portraits of the elderly street people of the Downtown Eastside, an activity requiring active participation by her subjects and ultimately reflected back to the community through a showing at a local gallery. This reciprocal approach to documentation positions art as a mode of community activism, a facet of Hastings Street life that continues today. Although the gentrification of surrounding areas has concentrated social problems in the DTES, not all artist collectives have followed the trend of evacuating the area for safer and more profitable neighbourhoods. The recent re-development of the Woodward's block, incorporating Simon Fraser University's School for Contemporary Art, is set

**The film charts Madeleine's shifting positions by way of strategic location shooting. There is a wealth of sequences shot downtown, treated with different stylistic approaches to capture a range of tonal qualities…**

# VANCOUVER

*maps are only to be taken as approximates*

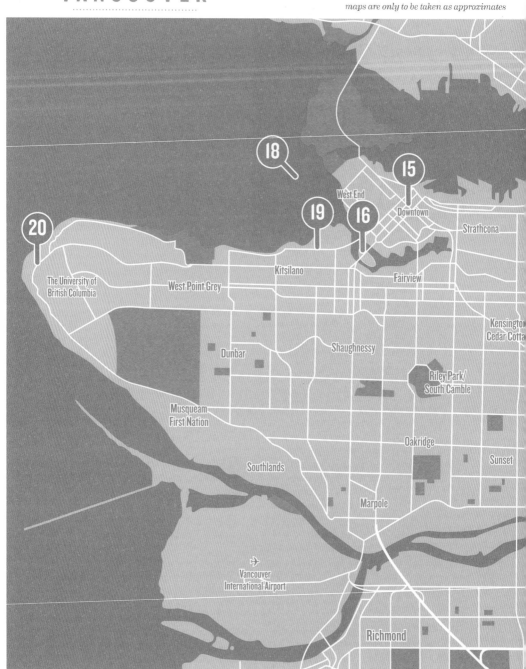

West End

Downtown

Strathcona

Kitsilano

Fairview

The University of
British Columbia

West Point Grey

Kensington
Cedar Cotta

Dunbar

Shaughnessy

Riley Park/
South Camble

Musqueam
First Nation

Oakridge

Sunset

Southlands

Marpole

Vancouver
International Airport

Richmond

# VANCOUVER LOCATIONS
## SCENES 15-20

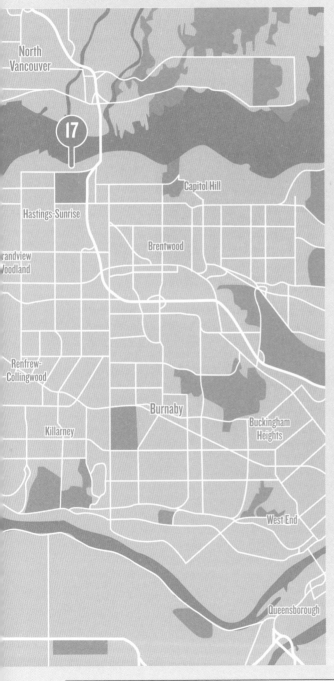

# SHOOT TO KILL (AKA DEADLY PURSUIT) (1988)

LOCATION *Robson Square*

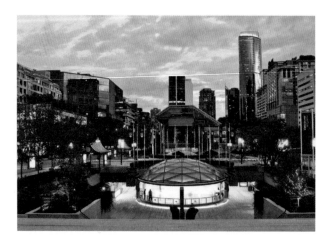

**FBI SPECIAL AGENT** Warren Stantin (Sidney Poitier) and a reclusive mountain man (Tom Berenger) track a deranged killer (Clancy Brown) and his hostage (Kirstie Alley) through the perilous wilds of northern Washington state, to small town, British Columbia and into downtown Vancouver. Stantin laments leaving San Francisco's urban and urbane comforts – theatre, music, access to a good meal at 4 a.m. What he finds in Vancouver is not quite so civilized: a frontier boomtown, just beyond the bush, where criminals live large in the British Properties and the local constabulary shrug shoulders a lot. Employing his 'big city' savvy and knowledge of the beast, Stantin nudges them all aside and takes charge of the hunt. He lays a trap for his quarry at Robson Square, Arthur Erickson and Cornelia Hahn Oberlander's vision of nature imported to the city, where tree and water are directed and regimented to soften the hard geometry of congealed and melted sand; where waterfalls mask traffic noise for chess players and office workers on takeout lunch breaks. As befits a rainforest, it's raining, lightly. Nature, mostly under control in the heart of the city. Or is it? There are wild animals lurking here, too: purse-snatchers ... and psychopaths. High Noon! The twelve o'clock horns blare out the first four notes of *O, Canada* from atop the nearby BC Hydro Building, province-builder WAC Bennett's monument to the power and wealth of nature harnessed. The prey is spotted, but smells a trap and bolts. The hunt continues. ↝ ***Elvy Del Bianco***

Photo © Paola Bacaro

*Directed by Roger Spottiswoode*
*Scene description: FBI agent and mountain man set trap for deranged killer*
*Timecode for scene: 1:28:57 – 1:31:33*

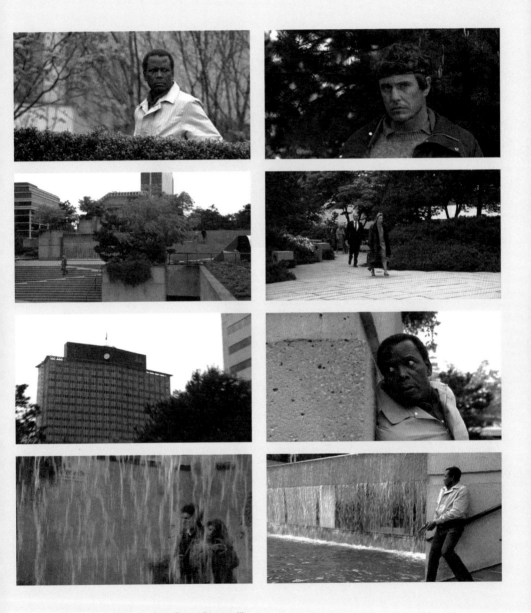

# COUSINS (1989)

*Granville Island Market*

**IN THE TRADITION OF AMERICAN REMAKES** of successful French films, Joel Schumacher's *Cousins* reimagines Jean-Charles Tacchella's charming *Cousin Cousine* (1975) as a standard romantic comedy with a box office-pleasing cast. Standing in for a farmers' market in Seattle, Washington Vancouver's Granville Island Market has changed little since 1989 – right down to the signage for the businesses depicted. The upbeat and colourful bustle of the lunch crowd among the produce and fish stalls of the market underscore the developing romantic relationship between Maria (Isabella Rossellini) and Larry (Ted Danson) at the same time as providing a very public location for Larry's display of anger and frustration. Shot in a clean, clear master and coverage style, this emotional scene builds rapidly as a seemingly 'in control' and pragmatic Larry evades Maria's need for a genuine response to their shared situation. Larry's sudden emotional and physical outburst brings the market to a halt – and acts to bring him and Maria closer together. ➻**David Hauka**

Photo © David Hauka

*Directed by Joel Schumacher*

Scene description: Maria and Larry confront their spouses' affair at a farmers' market
Timecode for scene: 0:28:35 – 0:30:58

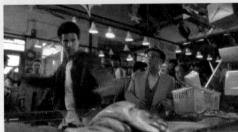

# DOUBLE HAPPINESS (1994)

LOCATION *New Brighton Park, New Brighton Road*

**DOUBLE HAPPINESS RAMPED UP** the Pacific New Wave, put Vancouver's multicultural condition on the indie-film map and hit the box-office hall of fame (under $1m but huge for a local picture). Producer Stephen Hegyes called it his University of British Columbia MFA thesis, which makes it a groundbreaking student film. Peter Wunstorf's eye-candy cinematography fits smartly on a modern widescreen display and enriches many top-notch performances, including charming discoveries Sandra Oh and Callum Keith Rennie. Shum builds a pleasing dramatic balance in the Chinese Canadian family: mother burns incense at the altar, daughter sneaks out to punk shows. Chinatown's bustle is nowhere in sight – the film is refreshingly free of ethnic clutter – except, pointedly, in what Jade (Oh) describes as the 'oriental love den' of a 'rice king'. Jade, 22, lives at home. Her family thinks she's made a shameful career choice in acting, and Hollywood's racial constraints offer little hope for success. She is forbidden all but the most respectable Chinese courtships, under threat of disowning. Then charming white boy Mark (Rennie) wins her over. She flees the morning-after bed, but Mark tracks her down in a playground where she swings, childlike – perhaps reliving a time when her dreams were less conflicted. He demands a romantic chance, and she gives in, for now. The scenery echoes Jade's conflict, and frames Vancouver precisely: the rubble of the old world that her family escaped, the natural poetic beauty she pursues in her art, the grey factory with its promise of drudging security. •❖*Flick Harrison*

Photo © Flick Harrison

*Directed by Mina Shum*
**Scene description: Mark convinces Jade to give him a romantic chance**
**Timecode for scene: 0:36:40 – 0:40:34**

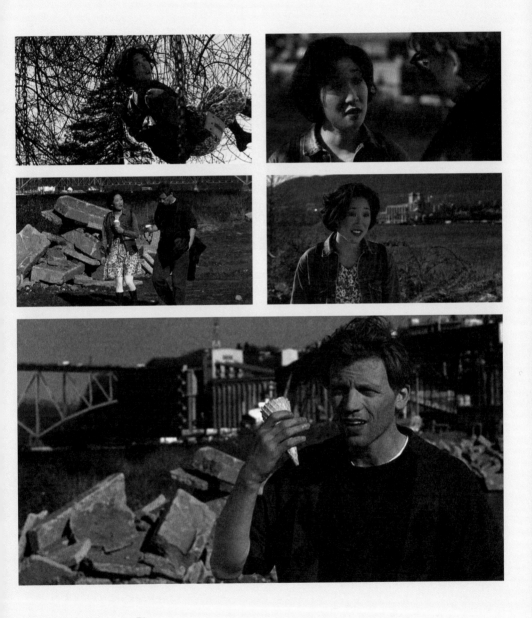

# DRIFT (1994)

LOCATION *English Bay*

**DURING THE SEVENTEEN MINUTES** of Chris Welsby's *Drift*, the camera pans back and forth, often seemingly impatiently or without an obvious direction, through the waters of Vancouver's English Bay. Most of the time, the camera lingers on cargo ships, which, through the combination of grainy 16 mm photography and heavy winter fogs, are transformed from gigantic commercial vessels into toy miniatures. While visually the film is quite sombre and melancholy, literally and figuratively permeated by the blues, the sonorous experience, largely consisting of the sounds of ocean, breaking waves and a steady rhythm of fog horns, is much more comforting (Bob MacNevin is credited for sound realization). In one scene, the camera strays from its marine playground and quickly pans right, allowing a short glimpse of a wedge of dry land – mostly trees, and a light from a passing vehicle or a lighthouse. This glimpse of Vancouver's Stanley Park lasts only a few seconds, as if to suggest that the camera eye made a mistake, followed by a pan back to the ships in the bay. Anyone who visited Vancouver will remember the predominance of blues, greens and earth tones in the architecture, the abundance of glass and water features, and the city's obsession with nature. In a way, the subject of *Drift* becomes a stand-in for Vancouver itself: a city that spends so much time contemplating the platitudes of nature that the urban experience itself is relegated to, at best, a supporting role.
**➻ Laurynas Navidauskas**

Photo © Sarah Banting

*Directed by Chris Welsby*
**Scene description:** *A short glimpse of land seen through winter mist*
**Timecode for scene:** *0:08:04 – 0:09:04*

# RUMBLE IN THE BRONX/HUNG FAN KUI (1995)

LOCATION *Kitsilano 'Kits' Beach, Arbutus Street and Cornwall Avenue*

**AS A PART OF THE CANADIAN** 'Hollywood North', Vancouver is an attractive place to shoot 'American' feature films because it can be used to suggest the topographical and cultural domains of a number of American cities that are cinematically alluring but prohibitively expensive to film in. In *Rumble in the Bronx*, the viewer is treated to Jackie Chan and Vancouver's ambitious iteration of a distinctive New York City borough. Most of the film was shot along Front Street, New Westminster where the film crew were required to add plenty of litter to the streets and paint fresh graffiti onto the walls to make the location look more authentically rundown. Yet, the sequence that shatters any illusion of fidelity occurs when Keung chases after a hovercraft, hijacked and dangerously manoeuvred by a member of White Tiger (Kris Lord)'s criminal syndicate. Expecting an audience to believe that Burrard Inlet could be the Hudson River, and that Pacific Boulevard could be a main Bronx thoroughfare, is cinematically plausible; geographical logic is strained, however, during the intermediary scene in which the hovercraft lands at Kits Beach with the North Shore Mountains conspicuously visible in the background. The entirely flat terrain of the Bronx is, of course, devoid of such a magnificent panoramic view. Here, Vancouver forcibly pushes through the shambolic American facade as though it were another part of Jackie Chan's highly improvised and equally entertaining, 'prop fighting' style.
�»*Carl Wilson*

Photo © Andy Ji

*Directed by Stanley Tong*
Scene description: Keung (Jackie Chan) chases a hovercraft across water and land
Timecode for scene: 1:09:46 – 1:14:37

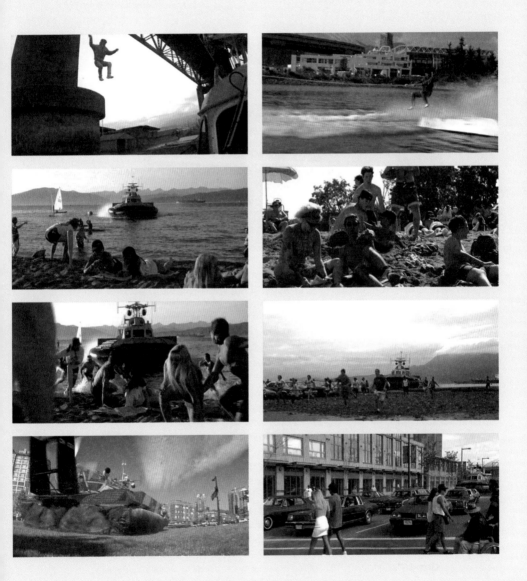

# KISSED (1996)

LOCATION *1783 West Mall, International House (exterior), University of British Columbia, University Endowment Lands*

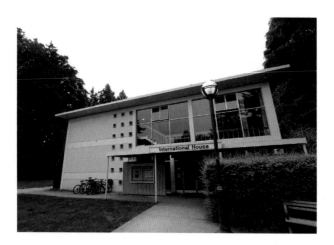

**NECROPHILIAC SANDRA LARSON** (Molly Parker) arrives at college with the stated aim of finding out more about the 'proper procedures' for working with cadavers. This class marks her third formal lesson about post-mortem, which started with the dissection of a frog in high school and continued when her boss at the funeral home, Mr Wallis (Jay Brazeau), demonstrated embalming techniques. In each instance, the discourse of learning appears distinctly gendered as a male instructor penetrates the deceased's abdomen with a metal implement (scalpel or trochar). The vigour with which the college professor wields the trochar over the class cadaver (played by executive producer John Pozer) carries overtones of violence. Sandra's reactions to these apparent violations become increasingly controlled, progressing from shock to revulsion and eventual stoicism, even though off-screen gasps are audible from her college classmates. Ultimately, her newly acquired calm demeanour and unruffled appearance belie the intensity of her more intimate understanding of death's incandescent energy. Based on Barbara Gowdy's short story 'We So Seldom Look on Love' (1992), *Kissed* was both Lynne Stopkewich's debut feature and her Master of Fine Arts project. The scene's UBC setting carries additional significance as the Department of Theatre, Film and Creative Writing fostered a group of young Vancouver film-makers who would form the vanguard of the Pacific New Wave in the late-1990s and early-2000s, including Bruce Sweeney, credited as a boom operator on this film. With her Genie Award-winning performance, Molly Parker would emerge as one of Vancouver's best-known actresses. **•Diane Burgess**

Photo © Kevin Doherty

*Directed by Lynne Stopkewich*
**Scene description: Sandra goes to college and attends a course on post-mortem**
*Timecode for scene: 0:32:28 – 0:33:02*

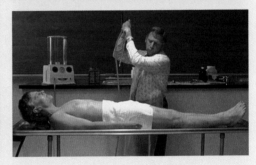

# THE BODY OF THE ACCUSED

Text by
AMY
KAZYMERCHYK

**VANCOUVER IS HERALDED** as a world film location; however, it is often a combination of the city centre, boundary city-municipalities and peripheral wilderness that are featured in cinema. *The Accused* (Jonathan Kaplan, 1988) is set in Vancouver's city centre and boundary city-municipalities, in locations that illustrate the social and economic traction between Vancouver, Metro Vancouver and the Province of British Columbia (BC) at that time. In 1983, neo-liberalism emerged in BC, deregulating labour and industry, dismantling rural development and social services, and privatizing economic authority and responsibility. *The Accused* exploits this tension, palpable in the geography, to aggravate the film's central conflict between the body and the state. The body belongs to Sarah Tobias (Jodie Foster), who has survived a gang rape. The state organizes the social and legal apparatus that accords this violence, represented by the defence for the men accused of rape and criminal solicitation, and

the media. Working-class, post-industrial and interstitial landmarks frame Sarah's body, while colonial and bureaucratic institutions located in the city's centre frame the state.

*The Accused* opens with an external shot of the 'Mill Bar', then called the Sidetrack Pub, and later the Tidewaters Pub and Grill which was destroyed by arson in May 2010. Located on River Road under the Alex Fraser Bridge, it faces the Fraser River. The bridge (Highway #91) is a major thoroughfare between Metro Vancouver's city-municipalities. River Road services lumberyards, tug docks, fisheries, RV sales lots and scrap metal yards along the south eastern shore of the Fraser, Vancouver's central working river. The Fraser's northern arm, separating just east of the Alex Fraser Bridge, is the southern boundary of Vancouver.

Sarah is a white, working-class waitress in her early thirties. She enjoys rock music, astrology, smoking pot and drinking to smooth out the edges. Sarah lives in a trailer in North Vancouver on the southern shore of Burrard Inlet, the northern boundary of Vancouver, a location framed by stacks of shipping containers, the Ironworkers Memorial Bridge and Cascadia Terminal grain elevators.

These locations are industrial transfer points – networks of highways, rail lines and waterways connecting warehouses, terminals, docks and elevators. As loci of mobile capital and labour, developed for transient and fluctuating employment and residency, these districts are vulnerable to absorbing the shock and trauma of social and economic restructuring. It is within this landscape that Sarah arrives at the Mill Bar to drink with her friend Sally after a fight with her boyfriend Larry. The bar is full of men –

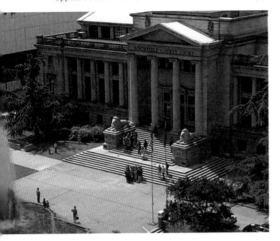

the fire place, 'Now I don't know what you got for selling me out, but I sure as shit hope its worth it!'

After a late night in the boardroom reviewing legal texts and contending with her guilt, Kathryn visits Sarah at her trailer with a plan to prosecute the men who cheered on the rape with criminal solicitation. By prosecuting the case in court, Sarah will be able to present her witness statement. The court proceedings are set downtown in the Vancouver Art Gallery, previously the BC Provincial Courthouse on Hornby Street, adjacent to the contemporary Vancouver Law Court designed by Erickson. The Vancouver Art Gallery is a neoclassical building designed by Francis Rattenbury in 1905. Rattenbury also designed the British Columbia Parliament Buildings and the Empress Hotel in Victoria. In the final scene of the film Sarah and Kathryn emerge from the courthouse, victorious on three accounts of criminal solicitation, and are mobbed by journalists and television cameras. Sarah is no longer passively witnessing her fate play out on television. She reclaims her voice as the victim and relinquishes her position as *The Accused*.

Concurrent with the making of the film, two serial crises of disappeared and murdered women persisted within comparable itinerant districts along industrial transfer points in BC: the Downtown Eastside Missing Women (since the early 1980s) and the Highway of Tears near Prince George, BC (since 1969). Likewise, the Vancouver Police Department, the defence for Robert Pickton, and state representatives in the public inquiry – who convened in the same Vancouver Law Court – also maintained a 'blame the victim' position against socio-economically vulnerable, racialized and indigenous women. These crises have been documented, investigated and critiqued in numerous films, including: *On the Corner* (Nathaniel Geary, 2003), *Unnatural and Accidental* (Carl Bessai, 2006), *Finding Dawn* (Christine Welsh, 2006) and *Survival, Strength, Sisterhood: Power of Women in the Downtown Eastside* (Alejandro Zuluaga and Harsha Walia, 2011).

*The Accused* is a dramatic film that nonetheless resonates with the impact that neo-liberal restructuring continues to have on women in Vancouver and British Columbia. *The Accused* presents an example of how ideological antagonism and socio-economic trauma are ingrained in geography and can be read in the landscapes and narratives of cinema. ✢

unemployed labourers, petty criminals, pensioners and college students. After a few drinks, rounds of pinball and slow dancing, Sarah is forcibly pushed onto the Slam Dunk pinball game and raped by three men in front of a cheering crowd.

Sarah's district attorney, Kathryn Murphy (Kelly McGillis), meets the accused rapists' defence team in a boardroom inside the Vancouver Law Courts in downtown Vancouver. Contrary to the Mill's dark, disreputable interior, the spacious boardroom overlooks Arthur Erickson's landmark late-modernist green-glass atrium. At the table, Kathryn backs down from charges of 'Rape One' to 'Reckless Endangerment' after one of the lawyers rebukes her: 'she walked into a bar, got loaded and stoned, and did everything but yank their dicks. No jury will buy her.' Conversely, a second lawyer pleads for his client's reputation: 'he's a kid of 22, he's an "A" student, he's got a future.' The defendant, Bob, is arrested outside of his frat-house, staged in Aberthau Mansion, a Tudor-style house in the wealthy West Point Grey neighbourhood. After watching a televised report claiming that the charges laid against the defendants were reduced because the alleged victim would not have made a strong witness, Sarah visits Kathryn at her modernist high-rise apartment overlooking the city. She interrupts a dinner party to cuss her out in front of a Milton Avery print above

**The Accused presents an example of how ideological antagonism and socio-economic trauma are ingrained in geography and can be read in the landscapes and narratives of cinema.**

# LOCATIONS MAP

# VANCOUVER

*maps are only to be taken as approximates*

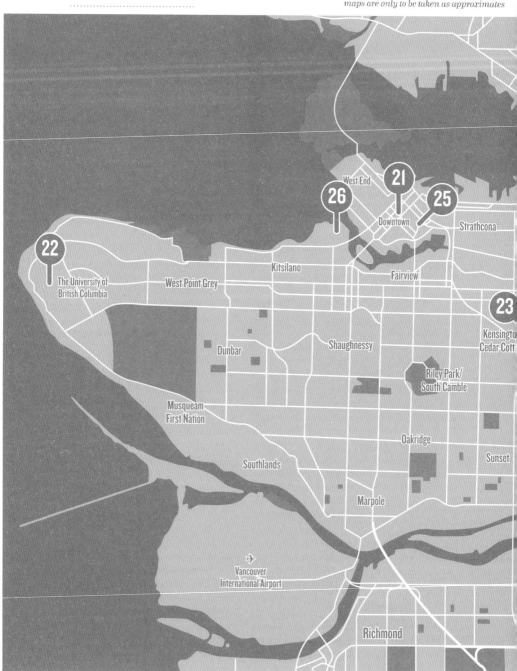

# VANCOUVER LOCATIONS
## SCENES 21-26

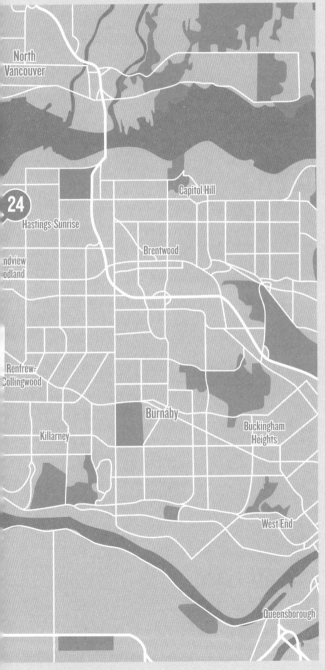

# HARD CORE LOGO (1996)

LOCATION *Commodore Ballroom, 868 Granville Street*

**BRUCE MCDONALD'S PUNK ROCK** faux-doc *Hard Core Logo* is the third in his trio of music-themed road movies. Four years after the band's break-up, front-man Joe Dick (Hugh Dillon) sets out to reclaim the glory days by organizing a reunion to support fellow musician, Bucky Haight (Julian Richings). Although the details of the shooting are suspiciously sketchy (one or both legs were amputated), Haight's alleged attack serves as a rallying cry for the Rock Against Guns tribute concert at the Commodore Ballroom. Built in 1929, this historic music venue has played host to genres ranging from swing to rock 'n' roll. The pre-concert set-up unfolds like a news report with several talking head interviews, including punk legend Joey Ramone and the on-camera introduction of McDonald as director. Rhythmic drumming that has accompanied the entire opening sequence builds as the source is revealed to be two street musicians seated outside the Granville Street entrance. An earlier sequence beneath the Save On Meats neon sign provides a reminder that the indie music scene once thrived on East Hastings at the Smilin' Buddha Cabaret. The concert's featured performers include Art Bergmann, Flash Bastard, the Modernettes and D.O.A., all mainstays of 1970s punk. Intercut with Hard Core Logo's performance of 'Who the Hell Do You Think You Are?' is backstage footage in which guitarist Billy Tallent (Callum Keith Rennie) confides to the crew that he may have secured a gig with another band; yet, in the concert's celebratory afterglow, it becomes apparent that Joe has other plans. **➻Diane Burgess**

Photo © Sarah Banting

*Directed by Bruce McDonald*
**Scene description: Punk legends reunite at the Rock Against Guns benefit concert**
**Timecode for scene: 0:04:01 – 0:11:22**

Images © 1996 Terminal City Pictures, Shadow Shows

# WRONGFULLY ACCUSED (1998)

LOCATION *Chemistry Physics Building, 6221 University Boulevard, University of British Columbia, University Endowment Lands*

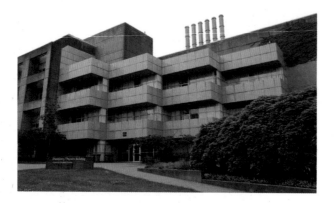

**ONE OF A SEQUENCE OF FILMS**, following *Airplane!* (Zucker-Abrams-Zucker, 1980), that uses Leslie Nielsen as the straight-man centrepiece in a whirlwind of parodies and visual jokes, Pat Proft's *Wrongfully Accused* takes Vancouver as the Minneapolis suburb of Columbia Heights, but the city is essentially untouched save for visual jokes. In this scene, Ryan Harrison (Nielsen), having temporarily escaped both the police and the conspiracy that framed him for murder as he pursues the one-armed, one-eyed, one-legged man who really committed the crime, emerges from a van filled with dirty diapers. Getting out of the van at the 4400 block of West Tenth Avenue, Ryan proceeds west, with flowers wilting, people fainting and magazines bursting into flame at his odor. Looking up, Ryan sees a sign and walks towards it; in the next shot he is three kilometres west, in front of the Chemistry Physics Building at the University of British Columbia, here dressed as 'McCarty Hospital', complete with a grotesque sign advertising artificial limbs. The shots do not match yet, once the space of the hospital is established, Proft uses the geography of this corner of UBC as it really exists. When Ryan, after more slapstick-based furthering of the plot, exits the hospital and steals a car, his incredibly conspicuous exit takes him and his pursuers back towards Vancouver proper. In this film Vancouver is intentionally generic, drawing attention to visual jokes: the city's architecture is exploited for its ability to unobtrusively mimic the setting of the films *Wrongfully Accused* parodies.
➼ *Neale Barnholden*

Photo © Kevin Doherty

*Directed by Pat Proft*
**Scene description:** *The fugitive investigates a hospital*
**Timecode for scene:** *0:49:44 – 1:04:46*

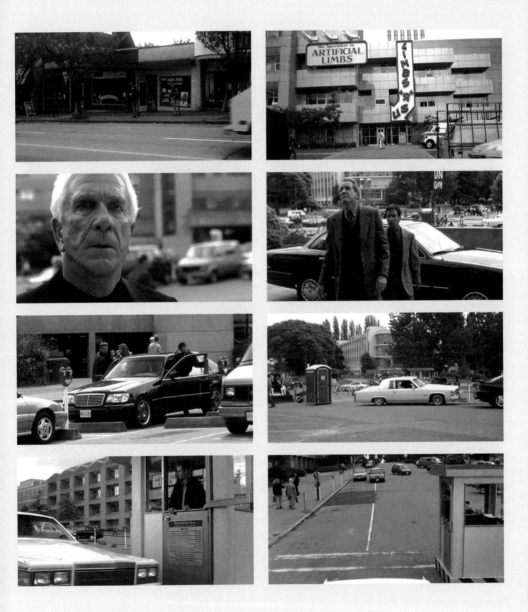

Images © 1998 Morgan Creek Productions, Constantin Film Produktion

# DIRTY (1998)

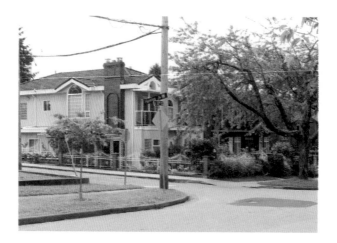

**DIRTY IS A FRANK, FRESH EXPLORATION** of fetishistic desires in which David (Tom Scholte), a Master's student, is having an affair with a groovy older woman named Angie (Babs Chula). His witless roommate Tony (Benjamin Ratner) is making a delivery of lumber in the area and decides to pass by Angie's house to buy some 'bud' unannounced. Angie admonishes him and warns him to always telephone her in advance, but is charmed by his social awkwardness and invites him in for a short visit. Inside they smoke a joint and sip red wine together, while talking and laughing. Unlucky Tony spontaneously asks Angie whether she has ever been married; this prompts a suddenly-apprehensive Angie to ask him to leave at once, ending the scene. The rather relaxed attitude towards marijuana depicted is shared along the West Coast of Canada and the United States – a cultural cliché, rarely represented. The sequence of Tony walking along 20th Avenue exposes for the first time in the film the neighbouring 'monster houses' built during the 1980s real-estate boom; they completely dwarf and set off Angie's rather modest wooden house from the 1920s, characteristic of the historical Kensington Cedar Cottage neighbourhood on the east side. The background images of the sequence make evident the ever-present process of gentrification throughout Vancouver – a well-represented motif in Sweeney's films. The inside shot of Tony and Angie on the couch faces north, through the window across 20th Avenue and up Fleming Street, a long interrupted residential street crossing the city north-south. **⇥Ger Zielinski**

*Directed by Bruce Sweeney*
**Scene description: Tony visits Angie to buy marijuana**
**Timecode for scene: 0:45:46 – 0:49:30**

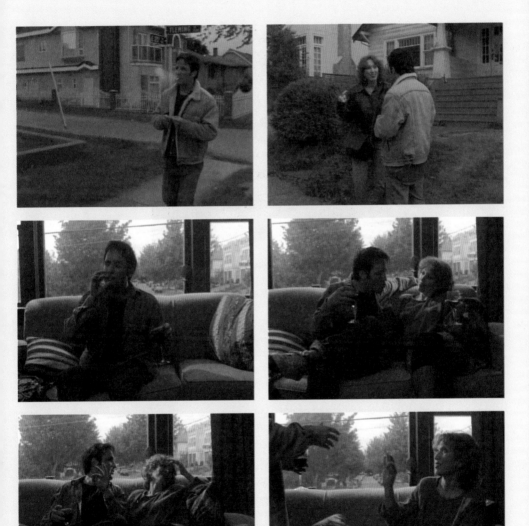

# BETTER THAN CHOCOLATE (1999)

*Grandview Park (near William Street and Commercial Drive)*
*followed by 'First and William' (actually Victoria and William)*

**WITH MERCHANDISE INTERCEPTED** at the border and deemed 'obscene', the plight of Ten Percent Books brings to mind the lengthy legal battle between Canada Customs and the West End's Little Sister's Book and Art Emporium, a case that reached the Supreme Court of Canada in 2000. However, the fictitious bookstore in Anne Wheeler's *Better Than Chocolate*, with its neighbouring Italian *caffè*, is clearly rooted in the community vibe of East Van. Along Commercial Drive, diverse cultures mix and mingle in the context of small independent shops, casual eateries and outdoor spaces. On a sunny day in Grandview Park, Maggie (Karyn Dwyer) finally meets Kim (Christina Cox), a newcomer whose timely arrival the previous night halted the intolerant advances of a group of skinheads. With her colourfully decorated van-cum-residence stationed at the curb, Kim sketches Tony (Tony Nappo), who eludes payment with the promise of free coffee and his family's homemade grappa. Yet, when the girls take him up on his offer, they find themselves turned out of the coffee shop as their same-sex affection ruffles Tony's more traditional values. They retreat to Kim's place, where one thing leads to another, until a tow truck quite literally shakes them out of their shared reverie. Wheeler effortlessly combines comedic moments with the sweet subtleties of burgeoning romance. During this sequence, time slows for extended beats as glances progress to a shared frame and then to intimacy; meanwhile, outside the van, fast motion cinematography captures the passage of the day as life carries on and parking privileges expire. **➾Diane Burgess**

Photo © Dennis Ha

*Directed by Anne Wheeler*
**Scene description: Maggie meets Kim and their romance begins**
**Timecode for scene: 0:07:44 – 0:14:33**

# LAST WEDDING (2001)

LOCATION *Hampton Inn and Suites, 111 Robson Street*

**LAST WEDDING TELLS THE INTERTWINED TALES** of three doomed young couples, whose relationships fall apart in a tripartite symmetry by the end of the film. In a previous scene the three couples have an awkward dinner together, where the weak seams in each relationship show. Shane and Sarah, one of the couples, are both architects. Shane is deeply committed to the idea of architecture as a crucial social practice, while Sarah has no issue with a free-market vision for the profession. At the dinner, their differing views spark rather blunt exchanges over the redevelopment of the former Expo '86 site into 'faceless' glass high-rises. It is at another of Vancouver's high-rises that Shane later joins Sarah at a posh corporate cocktail party. Whilst avoiding sweeping vistas, glimpses come through of the mountain range and other glass towers seemingly floating nearby. Writer Douglas Coupland makes reference to these structures in the title of his homage to Vancouver, *City of Glass* (2009). As Sarah introduces her boyfriend to her colleagues it becomes apparent to Shane that she had never mentioned his profession to them, which compels him to abandon the gathering abruptly. While the couple spars, the group keeps talking investments. Sarah then returns alone to her colleagues wearing a confident smile. ➔ ***Ger Zielinski***

Photo © Diane Burgess

*Directed by Bruce Sweeney*
*Scene description: Shane and Sarah argue at a party for corporate architects*
*Timecode for scene: 1:12:38 – 1:14:24*

# I'VE ... FOUND SOMEONE/KOI ... MIL GAYA (2003)

LOCATION *H. R. MacMillan Space Centre, 1100 Chestnut Street*

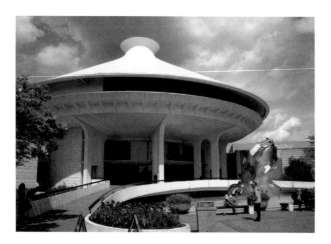

**PERHAPS I'VE ... FOUND SOMEONE** is a Bollywood knock-off of *E.T.* (Stephen Spielberg, 1982). Maybe it was inspired by the same Satyajit Ray story that Spielberg denies reading, but which Ray insists Spielberg stole. Surely the addition of musical numbers puts *I've ... Found Someone* in a universe of its own. Hrithik Roshan gives a funny, heartwarming and nonsensical performance as Rohit, brain-injured as a child in a car accident caused by aliens. Grown up but still mentally childlike, he accidentally calls the aliens back to Earth, and befriends a little E.T. named Jadoo. Jadoo gives Rohit superpowers, and so he wins his true love (Preity Zinta) and conquers a bully (Rajat Bedi). Early in the film, director Roshan plays Sanjay, Rohit's father, a scientist who contacts aliens by transmitting the sound 'om' (in a suspiciously familiar Kraftwerk tune). When the aliens respond, he rushes to a space research centre, located ambiguously in Canada. Although a multicultural bunch, the scientists laugh at the idea of Hindu aliens. Sanjay leaves, humiliated, later to die in that same car accident, and Rohit's mother (Rekha) takes the child back to India. This vague reference to Vancouver's Indo Canadian diaspora is a bit disorienting, and, despite what the dialogue said, the rest of the film seems stubbornly stuck in the Rocky Mountains. But if the MacMillan Space Centre, a blatantly touristic Vancouver landmark, can be passed off as a global S.E.T.I. headquarters, then maybe the magic of cinema and the economics of globalized production are more powerful than science and logic. ➥**Flick Harrison**

Photo © Andy Ji

*Directed by Rakesh Roshan*
**Scene description: World science authorities refuse to believe Sanjay has contacted aliens**
**Timecode for scene: 0:04:15 – 0:05:25**

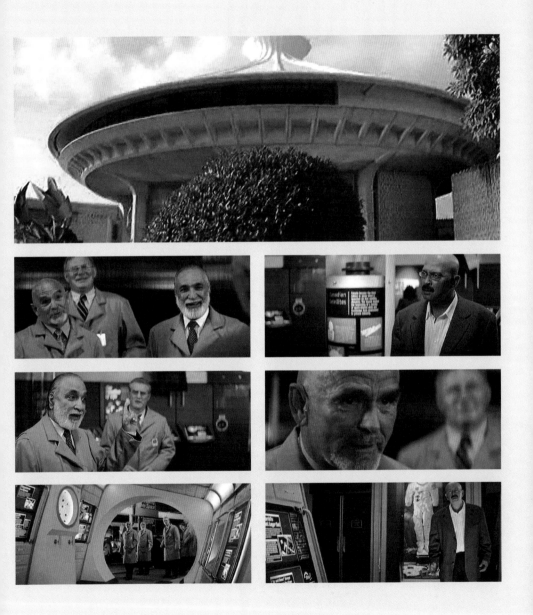

# KINK, POT AND SUSHI

## On Representing Vancouver in Bruce Sweeney's Films

Text by
GER
ZIELINSKI

**'It's not all Stanley Park in Vancouver! Some parts of this city are really disgusting.'**
*American Venus* (Bruce Sweeney, 2007)

**VANCOUVER-BASED INDEPENDENT** film-maker Bruce Sweeney consistently creates films that probe the politely ignored aspects of human relations, particularly their foibles, crises and failures, while selecting locations as meaningful settings in and around Vancouver. The locations are imbricated with the story itself, lending layers of nuance to the films. His first feature film *Live Bait* (1995) won an award at the Toronto International Film Festival. Since then, he has made four other films, *Dirty* (1998), *Last Wedding* (2001), *American Venus* (2007) and *Excited* (2009), with another currently in production.

Alongside such film-makers as Mina Shum and Lynne Stopkewich, he graduated from the University of British Columbia's MFA program in cinema and has been recognized as an important

force behind what Toronto critics named the 'Pacific New Wave' – the phrase itself did not arise from within the formation of a movement of film-makers banding together to some common aim. Arguably, what might unite these film-makers together is their fierce commitment to independent storytelling, namely, free of the constraints of Vancouver's highly-developed commercial film industry that largely caters to runaway film and television productions from the United States. Runaway productions are known for their strategic effacing of the location's meanings and posing it as either anyplace-whatsoever, a generic North American city, or as some other place in particular, such as Seattle or Boston. Vancouver's independent film-makers defy this logic of splitting location from setting, while certainly troubling and moving beyond any naive or calculated touristic gaze.

As Sweeney's films intimate, 'It's not all Stanley Park in Vancouver!' Remarkably, Sweeney avoids the temptations of easy visual pleasure provided by the natural landscape that skirts the city. While storytelling and the undergirding concept are clearly his emphasis, we notice glimpses of the natural environs in the background, behind the characters, without any dazzling gratuitous panoramic shots of mountains or seascapes; these are lived spaces, a part of the banal, taken for granted by the characters of the story and by the director. Nevertheless, Sweeney's films in no respect represent generic anyplaces-whatsoever. References to local neighbourhoods or districts are mentioned or visually represented on-screen. Those viewers unfamiliar with the city may not catch all of them, but the stories still speak through; the references add a certain depth of understanding to the city's representation.

*Live Bait* chronicles Trevor's attempt to leave his parents' home and brings to light his relation to members of his immediate family, his adulterous father, doting but manipulative mother, and sports-obsessed brother. Scenes of Trevor with his childhood friend Celia on UBC's campus are reminiscent of scenes of Woody Allen and Diane Keaton or Mia Farrow strolling together: their lively repartee and intellectualizing together; his failed amorous attempts with her indicate a lack of sexual interest. His romantic interest arrives in the form of grandmother-like figure Michelle, a self-confident artist and cricket player. Her transformative effect on the family is, perhaps, a distant echo of Pasolini's *Teorema* (1968). *Live Bait* displays the most natural landscape of all Sweeney's films, notably in the shot of Trevor seated in a small boat, with his back to his father and brother, gazing towards the camera. As he merges with the backdrop of islands and water near Nelson Island, on the Sunshine Coast north of Vancouver, it is implied that Trevor is contemplating his failed romantic situation and suspicion of his father's infidelity.

Sweeney's *Last Wedding* most directly references the city both in dialogue and in image. The film is thematically centred on the decline of relationships; it begins with three thirty-something couples and ends with the dissolution of all three relationships. Most of the film takes place well above ground, in each couple's apartment or loft, residences typical for their stage in life and career. While a crucial scene for the couple of architects takes place atop a hotel on glitzy Robson Street, it is preceded by a disastrous dinner party at the apartment of the newlyweds Zipporah – an unsuccessful country-western singer – and Noah – a weatherstripping salesman, which serves as a nod to the many hastily-built and now leaking condos from Vancouver's various real-estate booms. In contrast, Sweeney's earlier film *Dirty* combines a number of humble sites in the city, namely the West End and East End, and the nearly-extinct old-style lumber yard where David's roommate Tony works. Vancouver's industrial decline becomes the backdrop to the characters' misdirected sexuality: one afternoon, Tony and his female co-worker smoke up together before he initiates an audacious session of cunnilingus on site, ending in emotional awkwardness, and continuing Tony's bad luck with relationships of all kinds.

*American Venus* explores in greater depth Sweeney's interest in American-Canadian cultural differences. In *Dirty*, Angie and her mother are from the United States, but *American Venus* straddles the international border, which the three main characters cross several times. Here we witness the stereotypical hyper-driven American 'sports mom' who is desperately trying to force her figure-skater daughter to succeed. The teenage daughter escapes to Vancouver, historically known as the 'Sodom of the North' for Americans in western border towns, with its lower drinking age, strip clubs, cannabis and other recreational drugs, and safer night-time streets. Sweeney plays on the difference in US and Canadian gun control as the mother tries, desperately, to purchase a gun in the Downtown Eastside's 'cracktown', north of the infamous intersection of Hastings and Main. However, while street drugs are plentiful, guns are in short supply.

With respect to Sweeney's films made to date, this author would not claim that there is any trend or simple development in his use of Vancouver as material for his films, but rather a continuing commitment to the city and its representation as integrated with the stories he wants to tell. While his films are thematically driven, his deep knowledge and appreciation of Vancouver guides his choice in locations as settings, which keeps him true to his city and keeps his films layered and sophisticated. ✤

> **As Sweeney's films intimate, 'It's not all Stanley Park in Vancouver!' Remarkably, Sweeney avoids the temptations of easy visual pleasure provided by the natural landscape that skirts the city.**

# VANCOUVER

*maps are only to be taken as approximates*

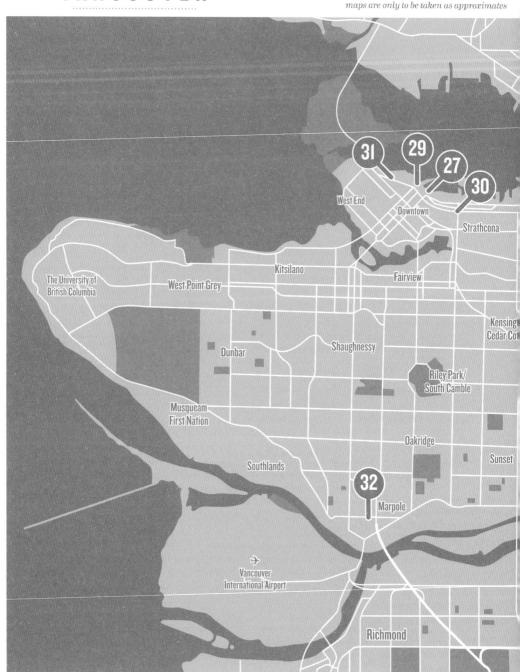

N

LOCATIONS MAP

West End

Downtown

Strathcona

Kitsilano

Fairview

The University of British Columbia

West Point Grey

Kensing Cedar Co

Dunbar

Shaughnessy

Riley Park/ South Camble

Musqueam First Nation

Oakridge

Sunset

Southlands

Marpole

Vancouver International Airport

Richmond

31 29 27 30 32

# VANCOUVER LOCATIONS
## SCENES 27-32

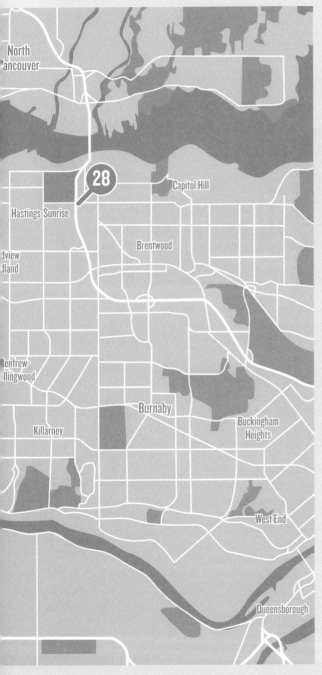

27.
BLADE: TRINITY (2004)
Waterfront Station,
601 West Cordova Street,
West Coast Express Platform
*page 80*

28.
I, ROBOT (2004)
Cassiar Tunnel, Highway 1
*page 82*

29.
FANTASTIC FOUR (2005)
The Marine Building,
355 Burrard Street
*page 84*

30.
FINDING DAWN (2006)
Main Street and Hastings Street
*page 86*

31.
EVERYTHING'S GONE GREEN
(2006)
588 Broughton Street
*page 88*

32.
SNAKES ON A PLANE (2006)
8660 Selkirk Street followed by
8625 Osler Street and South corner
of Osler and West 71st Avenue
*page 90*

# BLADE: TRINITY (2004)

LOCATION *Waterfront Station, 601 West Cordova Street, West Coast Express Platform*

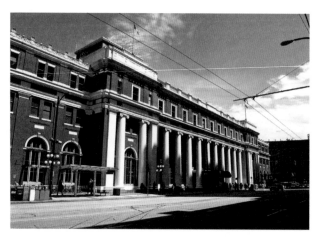

**DURING THE PRODUCTION OF** *Blade: Trinity*, the third film in the *Blade* franchise, writer-producer-director David S. Goyer publically discussed how he very much wanted the film rooted on location, in the real world amongst real people, as opposed to the largely studio-based production of the first two films in the series. Shot throughout the city of Vancouver, the film is deliberately set in an unnamed 'everycity' – a commitment to 'generality' that is emphasized by the decision to incorporate Esperanto as a subtle linguistic backdrop to the urban setting. Despite this intended anonymity, however, Vancouver's distinctive landmarks and personality consistently emerge over the course of the film. Vancouver's Waterfront Station, originally the site of the Canadian Pacific Railway's first depot in the city, and now a central terminus station in the city's public transit system, figures prominently in this scene, when we are first introduced to Abigail Whistler (Jessica Biel). Waterfront Station, situated in a grand and historic building, effectively plays against type, coming across dark, grimy and dangerous – the turf, it turns out, of roaming gangs of vampire thugs. Abigail, an avowed vampire hunter and daughter of Abraham Whistler (Kris Kristofferson), Blade's mentor and weapons engineer, appears initially disguised as a vulnerable mother carrying a young child. As the scene unfolds, however, she quickly turns the tables on this troupe of vampires, dispatching them with ease. As the last vampire falls, Vancouver's West Coast Express commuter train whizzes past the platform and Abigail disappears into the night. **•◦Peter Lester**

Photos © Maia Joseph

*Directed by David S. Goyer*
Scene description: Abigail emerges from disguise to demonstrate impressive vampire-fighting skills
Timecode for scene: 0:17:36 – 0:21:00

# I, ROBOT (2004)

*Cassiar Tunnel, Highway 1*

**DAVID PROYAS'S *I, ROBOT* EPITOMIZES** the postmodern paradigm as Vancouver is displaced and transferred to Chicago in the year 2035. Del Spooner (Will Smith) investigates the suicide of friend and roboticist Dr Alfred Lanning (James Cromwell) only to reach the false conclusion that a highly anthropomorphized robot, Sonny (Alan Tudyk), murdered him. While Sonny proves to have been loyal to Lanning, Spooner's discomfort with the rapid progression of technology is justified when robots begin to take control of the city. Crucially, the Chicago of 2035 must not be seen as a cityscape but as a screenscape – a city created by and for cinema – a distinction that foregrounds the gulf between the lived reality of Vancouver, 2003, and the digital utopia of *I, Robot*'s Chicago. In this scene, Spooner learns that his love interest, the robot psychologist Dr Susan Calvin (Bridget Moynahan), is in danger. Seeking to prevent her capture by a mutinous robot, Spooner races down an underground highway. Here, Vancouver's 730-metres long Cassiar Tunnel is digitally enhanced and extended. The usual traffic and dirt are gone, posing a visual dilemma for those who know it and reflecting the cinematic city's schizophrenic identity. In this way, *I, Robot*'s invisibly fragmented geography is typical of postmodernity's ambitious amalgamation: space and time are conflated as post-production combines Vancouver locations with CGI landmarks from present-day and (imagined) future Chicago. Vancouver is the real location of *I, Robot*'s urban facade, but it is ultimately engulfed by the abstract spatiality of simulated Chicago circa 2035. **⇢Edward Hyatt**

Photo © Dennis Ha

*Directed by David Proyas*
**Scene description:** Del Spooner races down a tunnel to save his love interest
**Timecode for scene:** 1:18:38 – 1:20:16

# FANTASTIC FOUR (2005)

*The Marine Building, 355 Burrard Street*

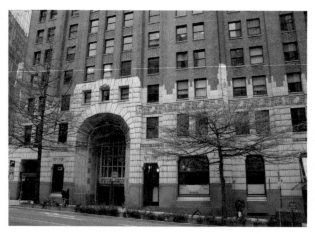

**ACCORDING TO THE MARVEL UNIVERSE**, the most prominent buildings of New York City are all inhabited by superheroes. The Fantastic Four's headquarters, the Baxter Building, is described in *Fantastic Four Annual #1* (1963) as 'New York's most famous skyscraper tower', but in the film, *Fantastic Four*, the comic's 35-story futuristic complex is replaced by a penthouse apartment of Vancouver's 1930s art-deco Marine Building. The film-makers opt for retro-authenticity with a nod towards the Golden Age (1930s–40s) style of comics. With a golden globe sitting atop of it, the Marine Building may be familiar to DC Comics fans as the exterior of the Daily Planet from the Superman based television show, *Smallville* (Miles Millar and Alfred Gough, WB and CB Networks, 2001–11). In the Marvel film universe, with a liberal application of CGI and futuristic props, the Marine Building is a central location in Tim Story's twenty-first century depiction of the Fantastic Four. The first time the structure is seen, it is from a dramatic, airborne establishing shot. With a downward tracking shot, striking music, an NYPD escort and a cheering crowd, four friends enter the building for the first time as a group of superheroes. It is in this space that the Fantastic Four bond and test the limits of their newly found talents, and it is here that they are challenged to use those skills to defend each other. Stan Lee has a cameo in the lobby, but for once he may be outshined – by the opulence of the Marine Building's marble and gold interior. ⤳*Carl Wilson*

Photos © Andy Ji

*Directed by Tim Story*

Scene description: The Fantastic Four are escorted home to a heroes' welcome
Timecode for scene: 0:42:36 – 0:45:16 (extended edition)

# FINDING DAWN (2006)

LOCATION *Main Street and Hastings Street*

'**I LOVED DAWN, AND IT'S UP TO ME** and my family to stand by her and let it not be forgotten,' says Lorraine Crey in *Finding Dawn*. Lorraine's sister, Dawn, was an Aboriginal woman who went missing in 2000 from Vancouver's Downtown Eastside, one of Canada's most recognized impoverished neighbourhoods. Dawn is one of more than 60 women officially declared missing from the community, and one of more than 500 Aboriginal women who have gone missing or been murdered in Canada in the past twenty years. Tragically, Dawn's DNA was found on the Pickton farm, the site of one of Canada's largest serial killer investigations. But Dawn was more than a statistic or a headline in a newspaper, she was a person loved by her family and community. They come together with hundreds of other people each year on Valentine's Day for the Women's Memorial March in the Downtown Eastside, an event organized by the community to commemorate the lost and call for an end to the violence that women face in the area every day. While the Downtown Eastside is often the subject of public scrutiny for the violence and poverty endemic to the area, *Finding Dawn*'s depiction of the March show us that it is also a community, whose members join the women's families and friends to share their grief and love. *Finding Dawn* reveals the human faces behind the headlines and the statistics, and a community that honours the lives of the missing and murdered, and demands justice for their deaths.
**⇢Karrmen Crey**

Photo © Andy Ji

*Directed by Christine Welsh*
*Scene description: The Women's Memorial March*
*Timecode for scene: 0:14:35 – 0:21:07*

# EVERYTHING'S GONE GREEN (2006)

LOCATION *588 Broughton Street*

**PENNED BY LOCAL ARTIST AND AUTHOR** Douglas Coupland, *Everything's Gone Green* presents Vancouver as a city of surfaces, open to multiple interpretations. 'Green' references marijuana grow-ops, laundered lottery proceeds and, of course, the distinctive natural beauty of the surroundings. Yet, even as the film draws attention to local landmarks like the Brockton Point lighthouse and the Burrard Street Bridge, it also acknowledges the ubiquitous presence of Hollywood productions that disguise and re-purpose the urban landscape. Sidetracked on the way to a job interview, slacker Ryan (Paul Costanzo) crosses paths with Ming (Steph Song), a props supplier for local film shoots, whom he later invites to his housewarming party. As the tenant-caretaker in one of his brother's real estate ventures, Ryan is the sole occupant of one of the glass high-rises that dominate Vancouver's skyline. In *City of Glass* (2009), Coupland refers to these buildings as 'see-throughs', purchased in anticipation of the Hong Kong handover by foreign owners who then found themselves with no reason to emigrate. Ryan's mom deems the building 'minimal and bleak' while Bryce (J. R. Bourne) chides that he is 'enjoying the benefits of another man's property'. This response is actually sparked by the sight of his girlfriend Ming admiring a photograph taken when she accidentally stepped in front of Ryan's camera. Bryce moves the conversation out onto the balcony where Coal Harbour and the north shore mountains provide a stunning context for his competitive capitalist paranoia. Ryan appears slightly baffled by the notion of 'pre-emptive Darwinism' until Ming arrives to expose this macho posturing. •*Diane Burgess*

Photo © Maia Joseph

Directed by Paul Fox
Scene description: Ryan has a housewarming party
Timecode for scene: 0:31:46 – 0:36:19

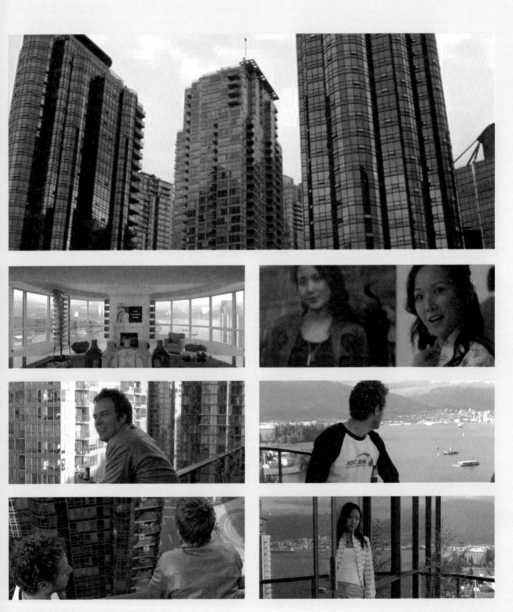

Images © 2006 Radke Films, True West Films

# SNAKES ON A PLANE (2006)

LOCATION *8660 Selkirk Street followed by 8625 Osler Street and South corner of Osler and West 71st Avenue*

**IN THIS TWO-MINUTE, ACTION-PACKED SCENE,** Neville Flynn (Samuel L. Jackson) and Sean Jones (Nathan Phillips) first meet and join forces in difficult circumstances. Having recently witnessed the murder of US prosecutor Daniel Hayes, Jones lays low in his Marpole apartment, which stands in for a tropical pad in Honolulu, Hawaii. He sits watching the news, hears a sound outside his door and goes to investigate. As he feared, the Triads have found him and are in the hallway preparing to attack. Jones quietly escapes to his balcony only to have Flynn grab him from behind. The mobsters enter the apartment, armed and dangerous. The *mise-en-scène* of Jones's apartment oddly combines hipster chic with tasteless bachelor, the 1950s chrome table and the floor lamp sitting awkwardly with the Red Bull, dart board, motorcycle posters, recliner and dirty laundry. Jones and Flynn make a break for it and leap over the balcony into the lane, palm trees and rubber plant distracting the audience from the large Pacific Northwest evergreen in the background. They run for Flynn's car and speed off, losing the criminal gang in a haze of burnt rubber. Once in the car, Jones and Flynn meet each other properly and the plot moves inexorably towards the snakes in the title. Marpole is one of Vancouver's oldest neighbourhoods, with evidence of inhabitation dating back to 3500 BCE, although its present character of stuccoed, walk-up apartments dates to the 1960s rezoning of the area, following the construction of the Oak Street Bridge in 1957. **↝ Angela Piccini**

Directed by David R. Ellis
Scene description: Flynn and Jones escape the Triads
Timecode for scene: 0:06:15 – 0:08:05

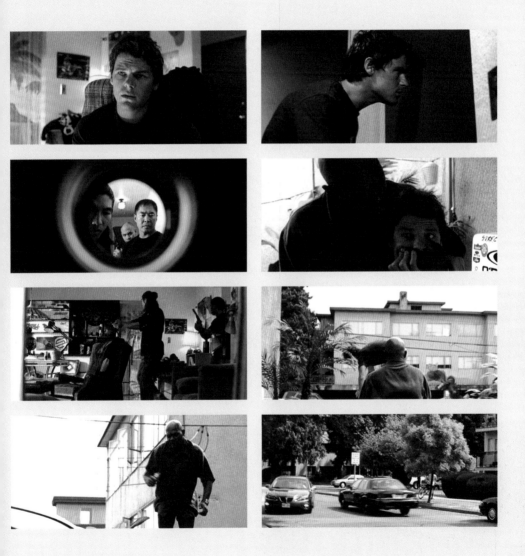

# THE HAUNTED PACIFIC

Text by
LINDSAY
STEENBERG

## *Vancouver on Crime Television*

**FBI AGENT FOX MULDER** (David Duchovny) meets with an inside source on a park bench in Washington, DC. Seattle residents struggle to deal with their grief over the murder of local teenager, Rosie Larsen. Boston morgue attendant Tru Davies (Eliza Dushku) uses her time-travelling abilities to solve crimes and save victims who died before their time. These American crime television scenarios have more in common than their genre: *The X-Files* (Chris Carter, Fox, 1993–2002), *The Killing* (Veena Sud, AMC, 2011–12) and *Tru Calling* (Jon Harmon Feldman, Fox, 2003–05) were all filmed in Vancouver.

On the small screen, as on the big screen, Vancouver frequently goes undercover as American cities – from Boston to Seattle. But what can this hyperreal mixture of American and Canadian urban centres tell us about the specificities of Vancouver and its citizens? And why has the crime genre, with its images of violence and violation, become the language through which Vancouver's neighbourhoods become so visible to the television-watching world? Has Vancouver come to stand as the world's generic crime scene? Answering these questions raises significant issues about how

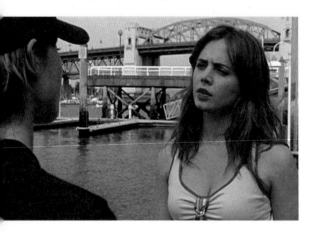

runaway production might contribute to a sense of community for Vancouverites, and, furthermore, about how the rest of the world sees an American translation of Vancouver that uses its landmarks and alleyways to flavour its risk-saturated urban crimeworlds.

In a volume looking to the screen incarnations of the city of Vancouver, it would be a serious oversight to ignore the city's rich representational life on television. The Canadian film and television industries are not wholly separate, sharing as they do production facilities and talent pools (directors such as Lynne Stopkewich; actors such as Callum Keith Rennie). Although television has prescriptive Canadian Content regulations that the film industry does not, programmers have always found creative ways to bend those rules, whether through substituting Canadian advertisements or through satire (as in *SCTV*'s [Bernard Sahlins and Andrew Alexander, Global, CBC, NBC and Superchannel, 1976–84] 'Great White North' sketch). In fact, television has become a major exhibition site and revenue source for Canadian productions and transnational co-productions. In terms of both policy and commerce, the medium of television is a key cultural site for artists to build and debate what it is to be Canadian, and what it means to be from Vancouver more specifically. What is surprising is the contribution that American producers of shows such as *Killer Instinct* (Josh Berman, Fox, 2005) and *Psych* (Steve Franks, USA Network, 2006–present) are making to these debates.

Vancouver is haunted by its American doppelgänger. To continue the gothic metaphor, there is an uncanny process at work for Vancouverites who watch American crime television and recognize places that for them are simultaneously familiar and strange. Familiar landmarks (the Lions Gate Bridge, the steam clock in Gastown, the Erickson designed concrete of Simon Fraser University) are now sites of violence and its investigation (a corpse washed up on

Above © 2005- Touchstone Television, Paramount Network Television
Opposite © 2003-2005 20th Century Fox Television

Jericho beach, a woman abducted by a serial killer from Coal Harbour).

Such uncanny identification of one's hometown provides both pleasures and perils to the Vancouver-based spectator. They are privy to the inside joke – this is not Seattle/Boston/Washington, of course, but Vancouver. Yet seeing such violence in the spaces that they visit everyday exacerbates the sense of risk already so prevalent in our culture. Jericho Beach becomes not just a leisure space but a threatening and horrifying crime scene. Both of these experiences create and reinforce a sense of community in the local spectator – bound together by their ironic and uncanny identification of their city in stories about American crime.

Citizenship in this spectator-community is also available to visitors and tourists to Vancouver. Bound to a longstanding tradition of literary tourism, there are tours of Vancouver that promise to take the spectator/tourist to the important locations of programmes such as *Twin Peaks* (Mark Frost and David Lynch, ABC, 1990–91), *The X-Files* and, more recently *Battlestar Galactica* (Glen A. Larson, Sci-Fi, 2004–09) – a programme that imagines the post-Apocalyptic future will look strikingly similar to the central branch of the Vancouver library. Crime TV has a significant impact in bringing tourists to

**In a *New York Times* review of *Da Vinci's Inquest*, Mike Hale urges American audiences to watch the show by concluding, 'You've already watched so many shows that were filmed in Vancouver; isn't it about time you watched one that's set there too?'**

Vancouver and shaping their navigation of the city itself during their visit. As Stijn Reijnders remarks of the role of landscape in European crime programmes like *Inspector Morse* (Colin Dexter and Tony Warren, ITV, 1987–2000), 'Not only do the TV detective programmes reproduce the existing tourist gaze; they also contribute to it at the same time' (Reijnders 2009: 172). The British Columbia (BC) tourist industry and large private companies such as Canadian Pacific Railway have historically been tied to the Canadian motion picture industry and have actively promoted Vancouver as a desirable and cost-effective filming location for American production companies. Vancouver's American screen avatar also offers another, distinctly hyperreal, tourist experience – see the world through Vancouver on-screen. Without leaving their hometown, Vancouverites can see Boston (*Fringe* [J.J Abrams, Alex Kurtzman and Roberto Orci, Fox, 2008–present], *Tru Calling*), Washington, DC (*The X-Files*, *The Lone Gunmen* [Chris Carter, Vince Gilligan, John Shiban and Frank Spotnitz, Fox, 2001], Seattle (*The Killing*, *21 Jump Street* [Patrick Hasburgh and Stephen J. Cannell, Fox, 1987–91], pilot episodes of *Criminal Minds* [Jeff David, CBS, 2005–present] and *House* [David Shore, Fox, 2004–12], Portland (*Mysterious Ways* [Peter O'Fallon, PAX, 2000–02]), San Francisco (*Killer Instinct*) and even Toronto (*Blood Ties* [Peter Mohan, Lifetime Television, 2007]). In a manner akin to Las Vegas's physical reproductions of the world's tourist landmarks, the screen version of Vancouver offers an economical postmodern tour of the world's crime scenes.

The glossy aesthetic of high-budget American programming often overshadows Vancouver's rich screenlife on locally produced and critically acclaimed crime shows such as *Da Vinci's Inquest* [Chris Haddock, CBC, 1998–2005], *Intelligence* [Chris Haddock, CBC, 2006–07] and *Cold Squad* [Julie Steward, Michael Hogan and Joy Tanner, CTV, 1998–2005]. In a *New York Times* review of *Da Vinci's Inquest*, Mike Hale urges American audiences to watch the show by concluding, 'You've already watched so many shows that were filmed in Vancouver; isn't it about time you watched one that's set there too?' (Hale 2007). While Vancouver's urban realities haunt American TV, shows like *Da Vinci's Inquest* tackle those local issues explicitly – whether that is drug problems in the Downtown Eastside or issues around the fair treatment of BC's First Nations people. ✣

*maps are only to be taken as approximates*

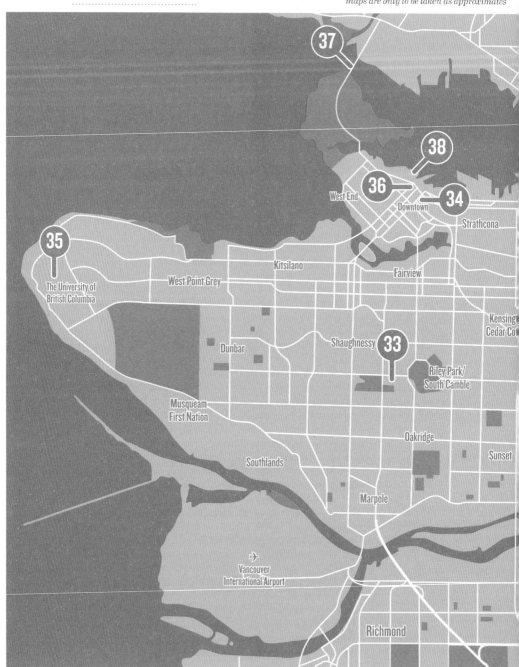

N

37

38

36

West End

34

Downtown

Strathcona

35

The University of
British Columbia

Kitsilano

Fairview

West Point Grey

Kensing
Cedar Co

Shaughnessy

33

Dunbar

Riley Park/
South Camble

Musqueam
First Nation

Oakridge

Sunset

Southlands

Marpole

Vancouver
International Airport

Richmond

# VANCOUVER LOCATIONS
## SCENES 33-38

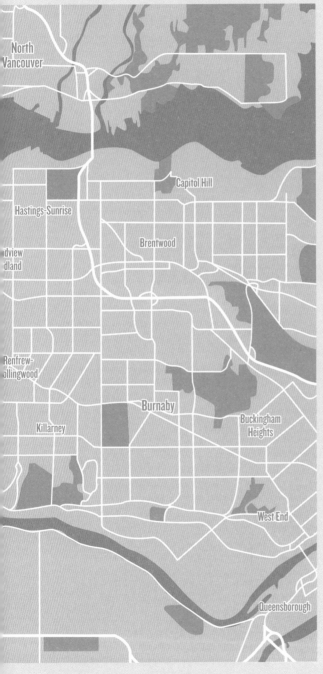

33.
JUNO (2007)
Eric Hamber Secondary School,
5025 Willow Street
*page 96*

34.
CRIME (2008)
Yagger's, 433 West Pender Street
*page 98*

35.
X-MEN ORIGINS: WOLVERINE
(2009)
Buchanan Tower, 1873 East Mall,
University of British Columbia,
University Endowment Lands
*page 100*

36.
RISE OF THE PLANET
OF THE APES (2011)
535 Hornby Street
*page 102*

37.
FINAL DESTINATION 5 (2011)
Lions Gate Bridge
(First Narrows Bridge)
*page 104*

38.
MISSION IMPOSSIBLE 4:
GHOST PROTOCOL (2011)
Vancouver Convention Centre West,
1055 Canada Place
*page 106*

# JUNO (2007)

*Eric Hamber Secondary School, 5025 Willow Street*

**THE TEENAGED JUNO (ELLEN PAGE)** has just informed her quasi-boyfriend, Paulie (Michael Cera), that she is pregnant and plans to have an abortion. His reaction ('Wizard ... You know ... I guess ... Just do whatever you want to do') did not overwhelm her. Now, we see her cycling to school to attend a science class in which, as always, Paulie will be her lab partner. She parks and secures her bicycle, goes to her locker, and accidentally drops some papers. A sporty boy mocks her and – showing the precocious insight that, just ten minutes into the movie, we already know is characteristic of her – she pauses to inform us that, secretly, 'jocks like him always want freaky girls' like her. In the laboratory, Juno and Paulie work with a pair of bickering classmates, Amanda and Josh (Candica Accola and Steven Christopher Parker), whose only concern is their ongoing argument over whether Josh recently cheated on Amanda. Juno and Paulie's rather more pressing problem is not discussed. The scene showcases two of *Juno*'s greatest strengths: the quirky, quotable dialogue of screenwriter Diablo Cody, and a fully convincing American high school setting. But this American high school is actually a Canadian high school. Although known as Dancing Elk School onscreen, it is in reality Vancouver's Eric Hamber Secondary School. Opened in 1962, Eric Hamber Secondary has educated a number of notable people, including a former Mr Universe and former Miss Earth. None of them, though, is quite as unforgettable as young Miss Juno MacGuff. ◆◆*Scott Jordan Harris*

Photo © Andy Ji

*Directed by Jason Reitman*
**Scene description: Juno goes to school**
**Timecode for scene: 0:11:26 – 0:14:05**

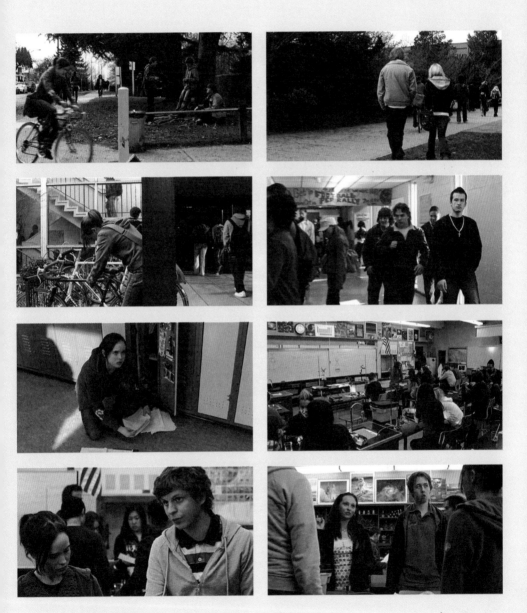

# CRIME (2008)

*Yagger's, 433 West Pender Street*

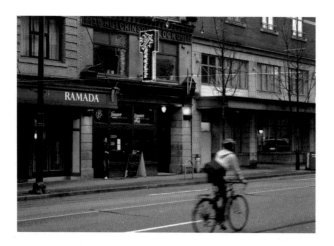

**CRIME IS AN OFFICIAL DOGME95 FILM,** obeying the Vow of Chastity, and each scene happens in one relentless take. Scholte, a UBC professor, made *Crime* with research grants – part of a growing trend towards art as research. His performances were central to the Pacific New Wave, which launched from the same school, so perhaps this film is a late ripple of that. Here Scholte plays the loser Brent, pot-smoking his way to the destitute bottom of the Downtown Eastside. His devoted girlfriend Tula (Scholte's wife Frida Betrani) is desperate to stay sober and hold their lives together, but Brent keeps sinking. She's forced to steal from her family to survive. Rick (Evan Lendrum) is a golden boy in a very different world: a hockey-star hero on his residence floor. When Rick's coke-sniffing buddies coax him back to their nasty world, running a yuppie bar in the Downtown Eastside, he starts repeating the mistakes he'd been trying to escape. The bar is a classic Vancouver intersection, where the neighbourhood's incoming gentry muscle out the nation's poorest, and here the two stories meet. Brent finds Tula, black-out drunk, and discovers she's lost her backpack and wallet. Lacking even bus fare, he steals a few dollars off a table. Suddenly Rick transforms into his violent alter-ego The Sheriff. With the law, the power and the crowd on his side, he humiliates Brent, then sends him off to jail and a downward spiral he'll never escape. ⟿ *Flick Harrison*

Photo © Flick Harrison

*Directed by Tom Scholte*
Scene description: Brent makes the mistake of stealing from Rick's bar
Timecode for scene: 1:24:20 – 1:28:00

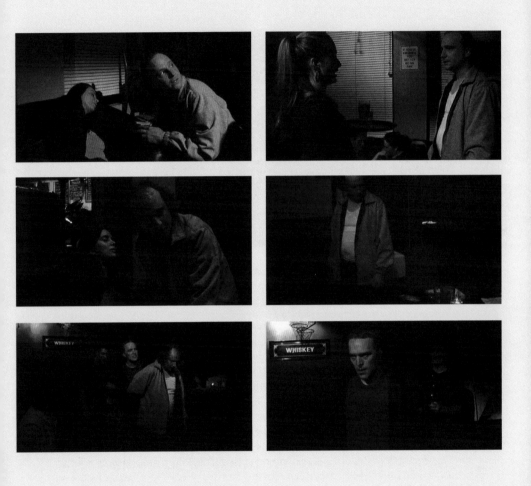

# X-MEN ORIGINS: WOLVERINE (2009)

LOCATION *Buchanan Tower, 1873 East Mall, University of British Columbia, University Endowment Lands*

**ALTHOUGH THE FIRST X-MEN FILM** was shot in Toronto, the following three films in the franchise all brought their sizable budgets to Vancouver. Notable locations include St Andrews Church as a hideout for Nightcrawler in *X2* (Bryan Singer, 2003) while *X-Men: The Last Stand* (Brett Ratner, 2006) frames the Sheraton Wall Centre as a 'cure' development facility. Vancouver and its landmarks have been used as a surrogate for American locales, which is usually plausible given the cultural similarities and the city's geographical diversity. However, *X-Men Origins: Wolverine* uses special effects to transform the University of British Columbia's Buchanan Tower into an even more distant location: a guerrilla military base in Lagos, Nigeria. This 1970s concrete tower, inspired by the architecture of Arthur Erikson, is transformed by the placement of tanks, armed barricades, a small army and a CGI shanty town in its surrounds. When unscrupulous government operative, William Stryker, orders his mutant commandos to infiltrate the base in a search for Adamantium, they proceed to destroy everything in sight without remorse. This is the first significant action scene in the film, and it is important in setting up Wolverine's emotional, motivational and biological changes, which eventually leads towards his famous relationship with the X-Men. Shot at night-time, thereby hiding some of the discrepancies that a 7500-mile bridge generates, the spectacular battle ground looks nothing like a Vancouver university campus, a testament to the versatility of both the production crew and the city. ⁺**Carl Wilson**

Photo © Kevin Doherty

*Directed by Gavin Hood*

*Scene description: Stryker's mutant commandos attack an African rebel army compound*
*Timecode for scene: 0:10:39 – 0:14:43*

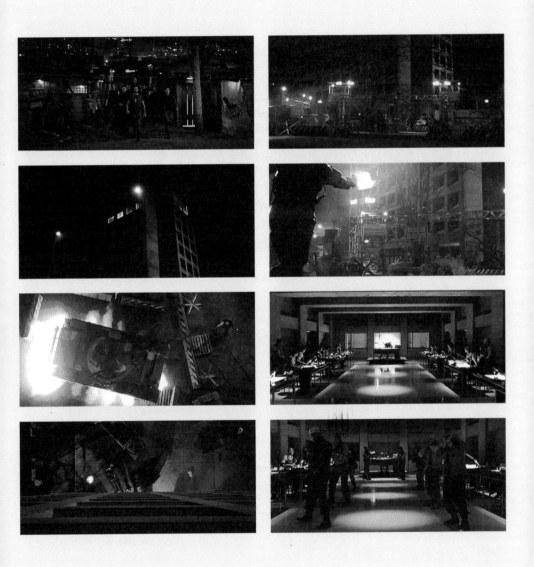

# RISE OF THE PLANET OF THE APES (2011)

*535 Hornby Street*

**RISE OF THE PLANET OF THE APES,** set in San Francisco but largely filmed in Vancouver, functions as a re-spun prologue for the original Planet of the Apes series. A pharmaceutical company, Gen Sys, is undertaking genetic therapy tests for Alzheimer's disease on apes. One ape, Bright Eyes, begins showing increased intelligence. As a board meeting ensues to discuss the results, Bright Eyes goes berserk and is subsequently executed by security. Unbeknownst to them she was protecting her newborn baby. Will Rodman (James Franco), the scientist overseeing the project, sneaks the baby ape home, naming him Caesar. Caesar grows up with Rodman and his Alzheimer-stricken father (John Lithgow), the young chimp exhibiting increased intelligence similar to that of his mother. After one of several incidents of conflict with a neighbouring family, a court order sends Caesar to an abusive primate sanctuary. Here Caesar, disheartened with humanity, begins a rebellious uprising. The climactic scene, shot in downtown Vancouver's Hornby Street, is where the city most parallels San Francisco: one North American business district seamlessly stands in for the other as a battalion of CGI apes descends, scattering civilians and destroying offices. Outside Hornby Street's YWCA fitness centre, orang-utans and gorillas attack two police cars – imports to the location featuring the San Francisco department's star and eagle insignia. Subsequently, Vancouver locations give way to a digitally rendered San Francisco as the rampant apes hijack one of the Californian city's famous cable cars en route to the Golden Gate Bridge – filmed on green screens in Vancouver – for the climactic battle. ⇢***Alex Nicola***

Photo © Maia Joseph

*Directed by Rupert Wyatt*

**Scene description: A CGI battalion of apes descends on the city**

**Timecode for scene: 1:21:18 – 1:23:08**

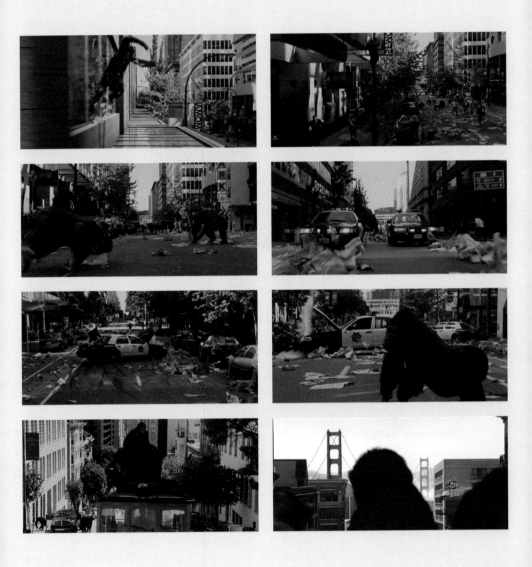

# FINAL DESTINATION 5 (2011)

LOCATION *Lions Gate Bridge (First Narrows Bridge)*

**FOLLOWERS OF THE FINAL DESTINATION SERIES** are no doubt familiar with its distinctive narrative formula. A handful of characters manage to elude catastrophe during a typically elaborate opening set piece, and by therefore cheating death, are systematically killed off in increasingly horrific scenarios throughout the remainder of the film. In the fifth entry in the series, Vancouver's First Narrows Bridge, more commonly known as the Lions Gate Bridge, has a starring role as the film's initial site of destructive mayhem. The suspension bridge, with a name derived from the twin mountains known as the 'lions' that occupy the skyline to the north, was built in 1937–38 to link downtown Vancouver (via Stanley Park) with the city's north and western suburban communities. As the scene opens, a bus carrying our lead characters towards a company retreat passes through Stanley Park and encounters construction midway across the bridge. A series of ominous details imply all is not well, and within seconds the bridge's suspensions come undone and chaos is unleashed as characters frantically, and unsuccessfully, try to escape. Just as our lead character Sam (Nicholas D'Agosto) is graphically bisected by a falling sheet of metal, he awakes from what was in fact a premonition dream – with only minutes to warn his colleagues of the imminent danger. A curious, although possibly entirely coincidental, meaning to the significance of the bridge's destruction in the film is that it is, of course, the namesake of one of New Line Cinema's leading competitors, Lionsgate Entertainment – a fitting and playful jab at a rival in the horror genre. **↝ Peter Lester**

Photo © Maia Joseph

*Directed by Steven Quale*
*Scene description: Sam and colleagues narrowly escape a collapsing bridge*
*Timecode for scene: 0:11:40 – 0:21:30*

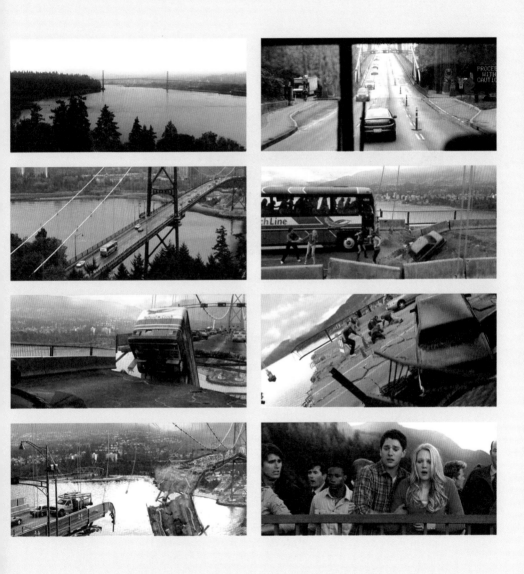

# MISSION IMPOSSIBLE 4: GHOST PROTOCOL (2011)

LOCATION *Vancouver Convention Centre West, 1055 Canada Place*

**AT THE CLIMAX OF BRAD BIRD'S** entry in the Mission: Impossible series, Ethan Hunt (Tom Cruise) and his allies have finally caught up with Kurt Hendricks (Michael Nyqvist), the man who framed them. Hendricks' plot is to use an Indian telecommunications satellite and stolen launch codes to ignite a nuclear war. For Hunt and the disgraced Impossible Missions Force, the mission comes as close as possible to failing: the missile pointed at San Francisco has been launched even as the team confronts Hendricks and his henchmen. Racing from the Mumbai headquarters of the telecommunications uplink, Ethan pursues Hendricks through crowded streets. *Ghost Protocol*, Bird's first live-action movie, draws on the tradition of action movies glorying in dizzying set pieces in exotic locations: this movie destroys the Kremlin, climbs the Burj Khalifa in Dubai, and attends a swanky dinner party in Mumbai. The transformation of the Vancouver Convention Centre into a Mumbai street scene is perhaps the most surprising use of Vancouver in this globetrotting adventure. The street outside the Convention Centre is crowded with cars and crowds, and the building itself is ornamented with a computer-generated tower that becomes the setting of the next scene. This brief scene relies on visual shorthand (bright saris, British cars and apparently inaccurate details) to remind us of the global stakes of the sequence, but by transforming one of Vancouver's newest prominent buildings, *Ghost Protocol* serves as a reminder of how interchangeable international locations can be. ➙ **Neil Barnholden**

Photo © Andy Ji

*Directed by Brad Bird*
*Scene description: Ethan Hunt pursues Hendricks through a Mumbai street*
*Timecode for scene: 1:52:50 – 1:53:33*

# GO FURTHER

Recommended reading and useful online resources

## BOOKS

**Dreaming in the Rain:**
**How Vancouver Became Hollywood**
**North by Northwest**
by David Spaner
(Vancouver: Arsenal Pulp Press, 2004)

**Hollywood North:**
**The Feature Film Industry in British Columbia**
by Mike Gasher
(Vancouver: UBC Press, 2002)

**Reel Vancouver: An Insiders Guide**
by Ken MacIntyre
(Vancouver: Whitecap Books, 1996)

**On Location:**
**Canada's Television Industry in a Global Market**
by Serra Tinic
(Toronto: University of Toronto Press, 2005)

**City of Glass:**
**Douglas Coupland's Vancouver**
by Douglas Coupland
(Vancouver: Douglas and McIntyre, 2009, rev. edn)

**Vancouver:**
**Representing the Postmodern City**
Ed. by Paul Delany
(Vancouver: Arsenal Pulp, 1994)

**Fantastic Four, Annual #1**
(New York: Marvel Comics, 1963)

**'"CSI: Vancouver"? Well, Not Exactly'**
by Mike Hale
*New York Times* (25 November 2007)

**'Watching the Detectives:**
**Inside the Guilty Landscapes of Inspector Morse,**
**Baantjer and Wallander'**
by Stijn Reijnders
*European Journal of Communication* (24: 2, 2009)
pp. 165–81

**'Exile on Hastings and Main Street:**
**The Vancouver Films of Larry Kent'**
by Dave Douglas
*Canadian Journal of Film Studies/Revue*
*Canadienne d'Etudes Cinématographiques* (5: 2, 1996)
pp. 85–99

**'Vancouver Asian: West Coast Film Cultures,**
**on the Rim and at the End of the Line'**
by Su-Anne Yeo
In Elaine Chang (ed.), *Reel Asian: Asian Canada on*
*Screen* (Toronto: Coach House, 2007)
pp. 112–23

**'Everywhere and Nowhere: Vancouver,**
**Fan Pilgrimage and the Urban Imaginary'**
by Will Brooker
*International Journal of Cultural Studies* (10: 4, 2007)
pp. 423–44

## ONLINE

**Vancouver International Film Festival**
*http://www.viff.org/*

**YVR Shoots**
*http://yvrshoots.com/*

**Ruins In Process: Vancouver Arts in the Sixties**
*http://vancouverartinthesixties.com/*

**Storytellers in Motion**
*http://urbanrez.ca/sim/storytellers-in-motion-01.html*

**'On Location 1 + 2'**
*http://tinyurl.com/a7decpq*

**NFB (National Film Board)**
*http://www.nfb.ca/*

**'Know who you are'**
by Debra Sparrow
*http://tinyurl.com/afkt2s3*

**'Media Activists for Livability: An NFB**
**Experiment in 1970s Vancouver'**
by Jean Walton
*http://www.ejumpcut.org/currentissue/*
*JeanWaltonNFB/index.html*

**Survival, Strength, Sisterhood: Power of Women**
**in the Downtown Eastside**
by Alejandro Zuluaga and Harsha Walia (dir.)
(Vancouver: Independent, 2011)
*http://vimeo.com/19877895*

# CONTRIBUTORS

*Editor and contributing writer biographies*

## EDITOR

**RACHEL WALLS** wrote her Ph.D., titled 'Visibility in Vancouver: Screen Stories and Surveillance of Vancouver's Downtown Eastside' (2011), at the University of Nottingham. She has taught film at the University of Nottingham, Broadway Cinema, Nottingham and, most recently, at Crisis Skylight, Oxford. Now a careers adviser at the University of Oxford, she enjoys membership of Oxford's International Cinema Club, and tweets about film, politics and careers as @rewalls.

## CONTRIBUTORS

**NEALE BARNHOLDEN** spent his childhood in Vancouver's Kensington-Cedar Cottage neighbourhood, on the Sunshine Coast, and in Kitsilano. He holds a BA in Film Studies and Honours English Literature from the University of British Columbia, as well as an MA in English Literature from UBC. He is currently a student in the Ph.D. program in the Department of English and Film Studies at the University of Alberta. His dissertation examines the relationship between the supernatural and historiography in Victorian fiction. He has worked at a video store in Kitsilano, and recalls fondly the changeover to DVDs when videotapes could be had at cut-rate prices. Neale's work has appeared in *The Journal of Popular Culture*, the *Dictionary of Literary Biography* and *West Coast Line*.

**ELVY DEL BIANCO** researches and writes on cooperative economic and cultural issues. In 2011 he curated and hosted Vancouver Sometimes Plays Itself, a series of mostly obscure films drawn from his personal collection and presented at the Waldorf Hotel. Elvy was born and raised on the moderately mean streets of East Vancouver, where he continues to drift and dodge.

**COLIN BROWNE** is a writer, poet, documentary film-maker and film historian with an interest in archival cinema. His films include *Linton Garner: I Never Said Goodbye* (2003), *Father and Son* (1992) and *White Lake* (1989), which was nominated for a Canadian Film Award as best feature-length documentary. He is on the board of directors of BC Film, the agency established to expand and diversify the film, television and digital media sectors in British Columbia, and the board of directors of the Vancouver International Film Festival. His catalogue essay, 'Scavengers of Paradise,' was published by the Vancouver Art Gallery during its 2011 exhibition on surrealism and explores the surrealist romance with the Northwest Coast and Alaska. His new book, *The Properties*, was published by Talonbooks in 2012. Browne teaches in the School for the Contemporary Arts at Simon Fraser University in Vancouver, British Columbia.

**DIANE BURGESS** holds a Ph.D. in Communication from Simon Fraser University, where her research focused on film festivals, national cinema and cultural policy. Her dissertation, 'Negotiating Value: A Canadian Perspective on the International Film Festival' (2008), examines the festival's intermediary role as a major institutional force in Canadian cinema culture. She has published on BC cinema, CBC balance policy, the legacy of Studio D and, most recently, on the relationship between federal funding and festival governance. Diane has taught film studies at the University of British Columbia and, from 2000–05, she was the Canadian Images Programmer for the Vancouver International Film Festival.

**KARRMEN CREY** is a Ph.D. student in Cinema and Media Studies at the University of California Los Angeles, where she is examining critical and interpretive approaches to Aboriginal film and media. She is originally from the Vancouver area, where she received two Bachelor of Arts: one in Art and Culture Studies from Simon Fraser University, and the other in First Nations Studies at the University of British Columbia. Prior to starting her doctoral program, Karrmen received her Master of Arts in Cinema Studies at the University of Toronto. Karrmen is Sto:lo from Pilalt territory near Chilliwack, British Columbia.

**SCOTT JORDAN HARRIS** is a British arts journalist and sportswriter. Formerly editor of *The*

*Spectator*'s arts blog and *The Big Picture* magazine, he is a culture blogger for *The Daily Telegraph*, a contributor to BBC Radio 4's *The Film Programme* and UK correspondent for Roger Ebert. His writing has been published in more than a dozen books on film and by, among others, *Sight & Sound*, *The Spectator*, *The Guardian*, *Fangoria*, Film4.com, BBC online, *Rugby World*, *Film International* and *The Huffington Post*. He is also editor of the *World Film Locations* volumes on New York, New Orleans, Chicago and San Francisco; and in 2010 his blog, *A Petrified Fountain*, was named by RunningInHeels. com as one of the world's best film blogs. He is on Twitter as @ScottFilmCritic.

**FLICK HARRISON** is a writer, media artist and film-maker in Vancouver with a B.Journ. (Hons) from Carleton University and an MFA from UBC. Starting out on the CBC youth series *Road Movies*, he has made videos in Pakistan, the United States, Mexico and China, and now serves in a City of Vancouver artist-residency pilot project as a member of Something Collective. His work includes teaching media to kids, engaging community through art, designing projections for theatre and dance, making music video, and international journalism and criticism for outlets like *Adbusters*, *Film Threat*, *Broken Pencil*, and *Terminal City*. Flick's videos have shown alongside work by Nick Zedd, Negativland, Seth Tobocman, Mike Holboom and Oliver Hockenhull. Flick blogs at www.flickharrison.com.

**DAVID HAUKA** received his MFA in Film and Creative Writing from the University of British Columbia in 2008 and is a member of the faculty at Capilano University's School of Motion Picture Arts. Films as director include *Certainty* (2009), *Dream* (2003) and *Impolite* (1992) as well as numerous music videos for artists such as Sarah Mclachlan, Lava Hay, Moev and Hilt. Hauka has worked as a director, producer and production manager for Universal, Miramax, MGM, Disney, CBS, ABC, NBC and the CBC. He was Co-Executive Producer of the award-winning feature film *Whale Music* (Richard J. Lewis, 1994), the first film to open both the Toronto and Vancouver International Film Festivals.

**EDWARD HYATT** is a postgraduate student at Kingston University London, with academic interests concerning Eastern European cinema, identity politics, and postmodern philosophy. His current academic research examines the shifts in culture and postmodernity following the economic crisis of the early 21st century. He is also a freelance photographer.

**RANDOLPH JORDAN** recently earned his

Ph.D. from the humanities program at Concordia University in Montreal. His dissertation, entitled *The Schizophonic Imagination: Audiovisual Ecology in the Cinema* (2010), examines the intersections between film sound theory and acoustic ecology through an analysis of films that explore ecological issues through their approaches to sound/image relationships. His current postdoctoral research project at Simon Fraser University extends this interdisciplinary methodology to consider how the study of film soundtracks can inform soundscape research on specific geographical locales. His case study of Vancouver draws on the research of the World Soundscape Project to inform an analysis of the representational aesthetics and production practices of Vancouver-based film.

**AMY KAZYMERCHYK** was born in Duncan, BC in 1980 and lives in Vancouver. She graduated with a Bachelor of Media Arts from Emily Carr University of Art and Design in 2008. She currently programs DIM Cinema, a monthly evening of artists' moving images at the Pacific Cinematheque and coordinates Events and Exhibitions at VIVO Media Arts Centre, one of Vancouver's oldest Artist Run Centres. She would like to thank Jeff Derksen, Cecily Nicholson and Colleen Nystedt for their contributions towards her writing, 'The Body of the Accused'.

**PETER LESTER** holds a Ph.D. in Communication Studies from Concordia University in Montreal, and is currently a postdoctoral teaching and research fellow in the Department of Theatre and Film at the University of British Columbia. His main area of research deals with exhibition studies and the history of film technologies, although he teaches a range of courses in film and media studies. Peter has recently published a number of articles and book chapters on the history of 16 mm film in Canada. He is currently adapting his Ph.D. dissertation into a book, tentatively titled 'Itinerant Images: Mobility and the Movies in Canada'.

**LAURYNAS NAVIDAUSKAS** is a film-maker and photographer exploring the themes of memory, surrealism and everyday life (www.navidauskas.com). He is a graduate of Simon Fraser University's School for the Contemporary Arts (BFA), and Simon Fraser University's School of Communication (MA). His directing credits include short documentary *Regarding Vancouver* (2010), exploring aspects of the quotidian urban experience. He is currently based in Toronto.

**ALEX NICOLA** received a 2.1 Honours degree in Film from Kingston University in 2011. During his studies, Alex displayed a raw talent and vision for

capturing the audience and bringing a creative and original flair to productions. He has strong ambitions to direct feature films, and is also passionate about script development. While his biggest inspiration as a director is Alfred Hitchcock, he also enjoys Tarantino's rehashes of popular culture. Alex is currently developing his own business which focuses on promoting independent film-makers. He lives in North London where his interests include music, boxing and martial arts.

**ANGELA PICCINI** is a senior lecturer in Screen Media in Drama: Theatre, Film, Television, University of Bristol. She publishes on practice-as-research, materiality, place and the moving image, with a current focus on screen media technologies and the Olympic city. Following a doctorate in Archaeology ('Celtic Constructs: Heritage Media, Archaeological Knowledge and the Politics of Consumption in 1990s Britain') from the University of Sheffield in 1999, she went on to work in public sector heritage before joining Bristol. Her co-edited books include *Contemporary and Historical Archaeology in Theory* (Archaeopress, 2007), *Contemporary Archaeologies* (Peter Lang Publishing, 2009) and *Practice as Research in Performance and Screen* (Palgrave Macmillan, 2009). She is currently co-editing the OUP *Handbook of Archaeologies of the Contemporary Past* (2013). She is on the editorial board of *Landscapes* journal. She is currently co-investigator on the AHRC-funded Into the Future project (Prof. Simon Jones, PI), Digital Economies-funded University of Local Knowledge project (Mike Fraser, PI) and AHRC-funded Connected Communities project (Prof. Robert Bickers, PI).

**LINDSAY STEENBERG** is a lecturer in film studies at Oxford Brookes University. Her work focuses on violence and gender in postmodern and post-feminist media culture. She has published on the subject of the crime genre in film and television and has recently completed a monograph on gender, violence and forensic science in the visual media entitled, *Forensic Science in Contemporary American Popular Culture* (Routledge, 2012).

**KAMALA TODD** is Cree-Métis and German. She was born and raised in the Coast Salish territory of Vancouver, and now raises her two young sons there. Kamala has a Master's degree in Urban Geography from the University of British Columbia. Her work as a community planner, film-maker and writer is focused on transforming the city to be more reflective and inclusive of Aboriginal people. She is creator of Storyscapes, an Aboriginal community arts project, and she is founder of Indigenous City Productions. Her film credits include *Sharing our Stories: The*

*Vancouver Dialogues Project*, (2012), *Indigenous Plant Diva*, (2008) and *Cedar and Bamboo*, (2009). She also worked as a writer and director on the children's Cree language series Nehiyawetan. Most recently, Kamala worked as a consultant and facilitator with the cross-cultural Vancouver Dialogues Project.

**MICHAEL TURNER** (b.1962, North Vancouver) is a writer of fiction, criticism and song. His fiction includes *Hard Core Logo* (1992), *The Pornographer's Poem* (1999) and *8 ×10* (2009), and his criticism has appeared in magazines such as *Art Papers*, *Art On Paper* and *Modern Painters*. He has contributed to the anthologies *Intertidal: Vancouver Art & Artists* (Morris and Helen Belkin Art Gallery, Vancouver/MuHKA, Antwerp, 2005), *Vancouver Art & Economies* (Artspeak, Vancouver, 2007) and *Ruins In Process: Vancouver Art in the Sixties* (Morris and Helen Belkin Art Gallery, Vancouver, 2008). A frequent collaborator, Turner has written scripts with Stan Douglas, poems with Geoffrey Farmer, and a libretto with Andrea Young. Recent curatorial projects include '"to show, to give, to make it be there": Expanded Literary Practices in Vancouver, 1954–69' at the Simon Fraser University Gallery, Burnaby, 2010, and 'Letters: Michael Morris and Concrete Poetry' at the Morris and Helen Belkin Art Gallery, 2012.

**CARL WILSON** is an independent writer with a specialized interest in 'indie' films and the work of Charlie Kaufman. Variously writing about reflexive gangsters, Hitchcock, German Expressionism, 'talkies', the Dream Factory, and whatever else takes his fancy, Carl's work has appeared in *Scope*, *PopMatters.com*, *Film International*, *The Essential Sopranos Reader*, the *Directory of World Cinema: American Independent* (vols. 1 and 2) and *American Hollywood* (vol. 1).

**GER ZIELINSKI** currently lectures in the Department of Cultural Studies at Trent University, Canada. He received his Ph.D. from McGill University and was a postdoctoral research fellow in the Tisch School of the Arts at New York University (2008–10). He has published criticism on contemporary art and experimental film as well as scholarly papers on the culture of film festivals, queer cinema, and underground film. Zielinski is researching and writing 'From Scenes to Seen: Cinematic Cities in Canada', which addresses the representation of Canadian and Québécois urban culture in a variety of types of films. His other two main book projects concern the transnational Underground scenes in Europe and the use of film festivals by selected social movements. Moreover, he wishes to thank Bruce Sweeney for graciously providing DVDs of his films and finding the time for an interview while in the middle of a film shoot.

# FILMOGRAPHY

*All films mentioned or featured in this book*